SECRET CHORLEY

Jack Smith

AMBERLEY

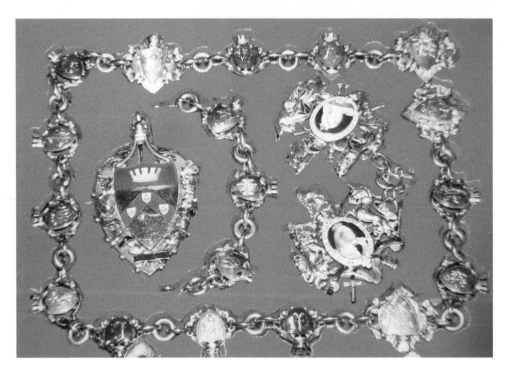

The Chorley Council mayoral chain of office.

First published 2017

Amberley Publishing
The Hill, Stroud
Gloucestershire, GL5 4EP

www.amberley-books.com

Copyright © Jack Smith, 2017

The right of Jack Smith to be identified as the Author
of this work has been asserted in accordance with
the Copyrights, Designs and Patents Act 1988.

ISBN 978 1 4456 6296 1 (print)
ISBN 978 1 4456 6297 8 (ebook)

British Library Cataloguing in Publication Data.
A catalogue record for this book is available from the
British Library.

Origination by Amberley Publishing.
Printed in Great Britain.

Contents

Introduction

I have studied the history of Chorley – my home town – for many years and often felt there were many less obvious aspects of its history to discover. There are many things or places we pass daily – in our own street perhaps – to which we may have said to ourselves 'I'll find out more about that one day', but never did.

Modern machines can demolish a street in a few days, and a multistorey mill can be cleared in a few months. Our heritage across the country is being nibbled away. Some things lost are minimal as regards their historical significance, but they were all a part, however small or insignificant, of our heritage.

Locally, over the past few years we have lost several buildings of interest, such as a former art deco cinema and cotton mills. Our street heritage is being lost too, with gradual disappearance of fan pattern cobbling work. Some tarmac-covered cobbles were recently removed in the town, but let's hope they will be re-laid. With the loss of another pub, we get a 'Youth Zone'. With the coming of a cinema complex, we lose more of the Flat Iron marketplace and the church on Hollinshead Street. A new block of flats in Fleet Street comes by losing the St John's Ambulance Hall and the mid-nineteenth-century Primrose Cottage.

The townscape has changed, and continues to do so. Many sites or features I have recorded have more planning proposals pending, such as the demolition of the Royal Oak and the former Odeon building. Some sites due for demolition have been saved to preserve the heritage of the town – Coppull Mill and Chorley's remaining square mill chimney (a reminder of Chorley's cotton spinning and weaving heritage) are two such examples. Other items rescued from demolition have been relocated or donated to alternative locations for display. Despite these successes, Chorley's physical heritage is diminishing and, along with it, some of its 'secret' history too – artefacts and documents, even tales passed down from memory. Stories, secrets, memories of old Chorley, and images are all part of our heritage and legacy. I hope to preserve a piece of it within these pages.

Our town motto tells us to 'Be Aware', this includes our heritage too!

Jack Smith
October 2017

1. From Then to Now

There are five places in northern England called Chorley. The one that is the focus of this book is in central Lancashire and the largest of the five, as well as being the only one that is known as a former cotton-spinning and weaving town – sadly spinning and weaving processes are now gone and their mills mostly demolished.

The town is located to the eastern edge of the Lancashire Plain, which extends westwards to the Irish Sea coast and Southport, less than 20 miles away. The foothills of the Pennines, with their high moorland areas, are adjacent to the east side of the town. Chorley has its roots in prehistory, as evidenced by several prehistoric burial sites on those moors as well as closer to the town itself.

Up until the 1950s, the town had virtually no known prehistoric sites, other than the moorland sites mentioned above. Two colleagues and I searched the upland areas for several years to try and find additional evidence relating to prehistoric periods. Evidence of flint tool and arrowhead manufacture was found that predated the Bronze Age. Flint flakes and tools were identified from their 'type of manufacture' and were found on

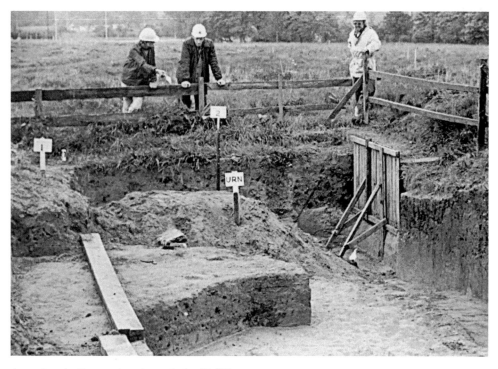

Assessing the Bronze Age site at Astley Hall Farm.

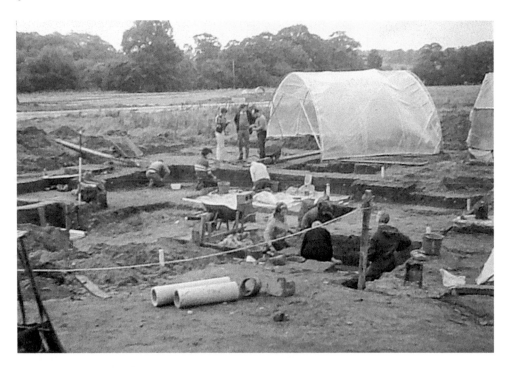

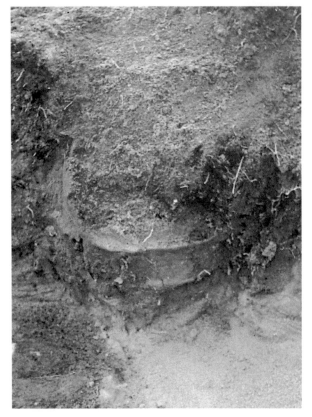

Above: The excavation underway at Astley Hall Farm.

Left: Astley Hall Farm. Burial urn in situ.

thirty small sites, all now overgrown by heather or whimberry. Some of the flints found dated from the Mesolithic period – between 8,000 and 5,000 years ago.

No firm evidence of prehistoric dwellings has been found locally; however, before recording or excavation could be carried out, suspected Bronze or Iron Age 'pit dwellings' were found on the west side of Healey Nab. Unfortunately, this site was lost when the M61 quarry was opened in the 1960s.

In lowland Chorley, at Astley Hall Farm, an excavation in the mid-1970s revealed a Bronze Age burial site. Five sets of cremated bones were found within a circular ditch – all female, with one accompanied by an infant – but there was no evidence of dwellings, despite much searching of excavated areas in the vicinity.

The Roman Period

We have no firm local evidence that any sort of building associated with the Romans was made in the Chorley area. They did, however, build roads to the east and west of the town.

By AD 59, Chester was held by the Romans, who had consolidated the land to the south and were planning their advance to cross the River Mersey at Wilderspool, then head on to Manchester. The advance northwards was via a military road from Manchester (Mamucium) to Ribchester (Bremetennacum) via Darwen, Blackburn and Mellor – the site of a signal station. They then went north from Ribchester towards Lancaster (Galacum). A road from Ribchester also went west towards Kirkham via Preston.

There is a second road from Manchester going towards Wigan, where archaeological excavation has uncovered several Roman structures, including a bathhouse. The Roman name of 'Coccium' has been assigned to Wigan, but no firm proof that this was indeed the case has been found. The line of the road north of Wigan has been found using topographical and geographical evidence; it is more difficult to configure from the ground, despite excavations at Standish and Coppull Moor.

Continuing north, this enigmatic road continues to Walton le Dale, where a Roman site – discovered in the 1940s – has been excavated. The site appears to be a civilian workshop, comprising huts with evidence of ironworking. It is likely that a road from this location would ford the adjoining River Ribble into Preston.

Another possible Roman road runs between Healey Nab and Anglezarke Moors, and could be classed as a secondary (or minor) road. My own investigations into this road are ongoing, with some successes. Regarding finds near here, at Heapey a small coin hoard was discovered along with a silver necklace – now in the British Museum. Then there is the enigmatic Roman amphora, which was found off Eaves Lane, Chorley. The story goes that this vessel – some 12 inches tall and around 9 inches in diameter – was found off Eaves Lane in the late nineteenth century. The vessel was given to my former colleague and co-founder of the Chorley and District Archaeological Society, Alderman C. Williams JP, in 1953. It was given to the well-known local historian on the understanding that the so-called 'jug' (the amphora) would remain with him as private artefact. Prior to the death of Mr Williams, in the presence of the late Mr John Rawlinson and Mr T. Rigby, he requested I became the keeper of that vessel, to which I agreed. I still honour the request of the finder's family, and that of my late colleague and friend, in that the alleged Roman amphora remains as a private item.

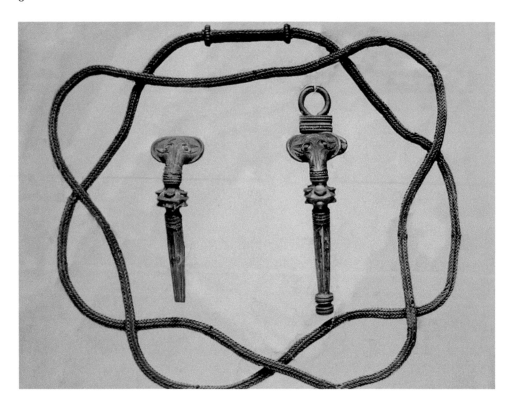

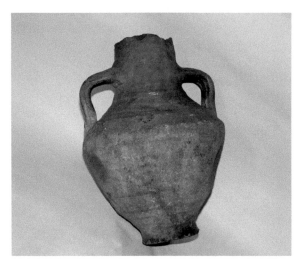

Above: Roman silver chain, found in Heapey.

Left: An alleged Roman amphora, found locally.

Although the existence of the two major roads is pretty certain – from Manchester to Ribchester and from Manchester (via Wigan) to Walton le Dale – neither road has had its route irrefutably proven and fieldwork is ongoing.

The third century of the Roman occupation of Britain saw the introduction of the Christian faith to the province. Roman coinage of the time shows religious symbols on

them. They may have been imported when the persons carrying them came to Britain, so it is uncertain as to whether the coins were minted in Britain or Europe.

Religious affairs of this time were of no concern to the resident officers and garrisons of the army, who were always on station policing areas, consolidating their forts and townships, or guarding the shores and hinterland places against uprisings or disputes. When the Roman army in Europe was in need of more support in AD 383, the British garrisons were removed by the army commander Magnus Maximus to support the European forces. He was unsuccessful in getting support to usurp the emperor and returned to Britain in AD 384 to resume his position of command. He remained here until AD 407, when Rome was in need of all its distant forces to return to help defend a city that was regularly being attacked by differing forces. From this time, the Roman armies were removed from Britain, leaving the now 'Romanised' Anglo-Romans to continue without military aid. Many of these residents held high office in the army and civil works, and many stayed in Britain when the armies were leaving. The administrative authorities in Britain, now undertaken by former Anglo-Roman administrators, were informed in AD 410 that Britain was no longer a Roman province.

Angles and Saxons

From c. AD 550–600, the Angles who lived on the east coast in the kingdoms of Deira and Bernicia (later Yorkshire and Northumbria) gradually moved west to settle in the river valleys of the Pennines and in suitable places on the low-lying coastal areas. These movements were generally unopposed by the people of this western area. There were still many disputes between tribal/kingship areas that escalated around the early seventh century; large raiding groups from both of the eastern kingdoms raided the west with a view to overtaking the British Anglo-Saxon kingdom. This attack led to a subsequent increase of the Anglian people into the former British kingdom from the ninth century.

Records from the time are contained in the *Anglo-Saxon Chronicles* and written by historians such as Bede and learned religious scribes in their isolated abbeys. They tell us that over time, and with intermarriage of the people, the only evidence left of the Anglo-British people were the names of the area or places they lived, which often had the 'inga' or 'tun' ending to their names. It is recorded that in the area of Lancashire, as it became, fifty such-named places exist. Locally we have Adlington, Anderton, Bretherton, Croston, Eccleston, Euxton, Rivington and Wrightington.

The British Saxons are perhaps the first real association we have to the written word. The *Chronicles*, referred to above, recorded much of what we know today about historical events and everyday information. Despite this recorded information, the physical evidence of the Saxon people is scarce, and is also largely based upon place name evidence for the location of their settlements. Saxon sites can be identified by places ending in 'ley' or 'lea' (pronounced 'lee-a'). Local examples include Chorley, Heapey and Tunley.

The first part of Chorley's name is derived from *ceorlea* (there are various spellings), which is thought to be of Anglo-Saxon derivation. The first part of the name, 'chor', is derived from the Saxon for a person or people. The last part of the name, 'ley', is Saxon

and means 'meadow' or 'field by a stream'. Thus we have 'Chor-ley' or 'ceor-lea', meaning 'people by the River Ceorle'.

Few external features of Saxon origin survive in Chorley today, but there are several internal features: several cruck buildings, such as in Rivington, Duxbury, Heskin and Euxton, have cruck frames made from wood that dates to the Saxon period.

A wooden chapel on the site of Chorley's parish church was probably the first church erected in Chorley during this period. It is possible that the earliest stonework for the first stone church and later foundations of the tower could also be of Saxon origin.

Early timber-framed cottages that were lived in by local Saxon workers no longer exist. The last possible local contender was a cottage in Runshaw Lane, Euxton, which was a complete timber-frame build with wooden wall supports and wattle and daub panels throughout. However, using photographic evidence, a fifteenth-century date was suggested.

The Vikings

The raids by the Norsemen began along the Britain's north-east coast, the north of Scotland and the north coast of Ireland around the period AD 780–90, with further landings in East Anglia, Jarrow and the Christian island of Lindisfarne. Raids continued on the islands of Orkney and Shetland, and settlements were established at both these

A sample of the Cuerdale Viking silver hoard.

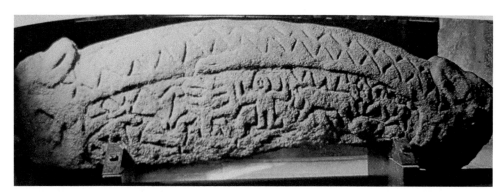

The Viking burial marker (Hogback Stone) from Heysham.

islands. The Anglo-Saxon communities were defenceless in most cases and the Norsemen had their pick of whatever they wanted. The *Anglo-Saxon Chronicles* contain details of some of these raids, such as in AD 865 and 871 when the chronicles tell us 'there were a great many ships in the raid'.

During the early 900s, many Norse families came from Ireland to the Lancashire coast and moved further inland to the established wide, curving area from East Anglia, then north-west almost to Cumberland. This was the Danelaw area, the main central region and the Norsemen's 'home from home'.

Despite a long period of settlement and peace, other raids by ships from the Viking countries took place in the 980s, and was only settled when an agreement between the Norse and Saxons was forcibly laid down. This agreement was that if the Saxons paid a set amount of money to the Danelaw governing body, the shipping raids would stop. Vast amounts of money were given to the Danelaw for some years. In 994, the equivalent of £16,000 today was paid, and in 1007 it was the equivalent of £36,000. Despite these payments by the Saxons, the sea raids continued.

We also have Norse associations with place names locally, such as Anglezarke with its Stronstrey Bank, Limbrick, Brindle and Brinscall.

Following a period of Norse mercenaries fighting for the Saxons and the abolition of the Danelaw, England at last had just one king: Aethelred in 1012. He was followed by his son Cnut in 1016, who reigned until 1035. Cnut was followed by King Edward and then Harold, who battled with the former king of the Danelaw and then, famously, with the Normans at Hastings in 1066.

The Normans

One of the features introduced by the Anglo-Saxons within the royal estate, which was all the land between the rivers ('betwixt Ribbel and Mersee'), was to separate the land into named areas based on their major lordship's manor dwelling. These areas were called wapentakes at first, and later hundreds. A total of six areas were established: Derbei, Neweton, Walingtune, Salford, Lailand and Blacheburn. The wapentake name was used from an older system of counting spears (or other weapons) when held aloft as in a vote when arms are raised 'for' or 'against' matters. The count of weapons being held up was

known as a 'weapons take', which established the number of people in any part of the wapentake areas.

The manorial lord of the wapentakes had a senior employee called a reeve to look after his immediate estate lands. The reeve was responsible for labour and cultivation work. Other parts of the manor land were allocated for cultivation to lesser individuals called drengs, who were freemen or thanes that rented the plot of land called a berewick. It was on this land that he would grow his own crops and perform service to the manor lord.

North of the River Ribble was a large tract of land extending in width from what became Yorkshire to the west coast, and, in length, north from the Ribble to Lonsdale – Lonsdale and part of Yorkshire were the two wapentakes. The vast tract of land with no manorial name was all classed as waste and called Agmundreness, later Amounderness, the Fylde and Wyre of today.

After the Conquest in 1066, a large portion of these lands were given to the Norman Roger de Poitou by King William I for his support in overcoming the British. As his new estates covered such a large area, Roger established his seat of power between Lonsdale and the River Mersey. He built his castle on high ground above the river in Lancaster, 30 miles north of Chorley.

The coming of the Normans in 1066 saw William Duke of Normandy crowed King of England in December that year. The subsequent twenty or so years were taken up with

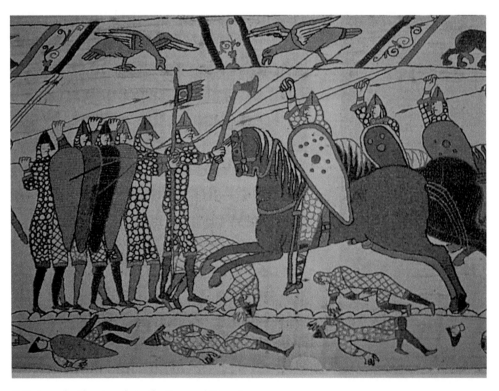

A Norman battle scene from the Bayeaux Tapestry.

Domesday Book.

learning about the land he now ruled and quelling both the constant internal uprisings and raids by the Norsemen.

The Saxon period had already established boundary areas of estate lands as well as a system of coinage. The incoming Norman leadership had a basic established lordship system of tenant farmers and workers. Despite this, the community that was to later

become Chorley was not mentioned in the Domesday Book (1086) as a separate township. In subsequent tenth- and eleventh-century documents, we find references to the 'ville of Cherlegh' within the wapentake of Lailand.

From the Twelfth to the Twenty-first Century

Like many similar small towns, several local noble families emerged from the twelfth century onwards. Family names such as Chorley, Charnock, Gillibrand, Duxbury, Standish and other lesser-known families are all involved with the growth of the town one way or another. The families had different religions and lived on separate estates with their own manor houses. They took part in wars; some were executed; one even sailed on the *Mayflower* to New England (Myles Standish).

DID YOU KNOW ?

The much-travelled sixteenth-century historian Leland visited Chorley in the year 1560, noting: 'Chorle, a wonderful poore, and no market.'

Corn grown on local estates was milled at water-powered mills along rivers such as Bagin (later Black Brook), Chor, Douglas (or Asland) and Yarrow through the intervening centuries, with improvements made to water storage and supply.

Animal wool was spun by hand in the home and even on the land. Wives of tenant farmers would supplement their meagre income by spinning the wool from their sheep or from a supplier, who would bring raw material to be spun and take away the spun yarn. A system was emerging. Weaving was done by crude hand-operated looms. Here, too, systems evolved with a so-called 'putter out' of wool or yarn.

It was the cotton industry that put Chorley on the map in the eighteenth century when Richard Arkwright, a Preston man who already had a cotton mill in Derbyshire, established a cotton-spinning mill at Birkacre in the 1770s. Chorley now had waterwheels to drive cotton-spinning machinery (called a water frame) that had been invented by Arkwright.

The 1790s saw the first steam-powered cotton mills built in Chorley, along with a canal from Lancaster to Wigan. The railway (from Bolton to Preston) arrived in Chorley in 1842. It was opened on completion of the Chorley Tunnel and the 'flying arches' of Alexander Adie in 1843. The stone arches were removed in 2013 and replaced two years later, after steel girder supports were fitted below them in 2015. Recent work in Chorley has seen a tunnel trackbed lowered, the station rails altered and the platforms extended during April and May 2017 in order to facilitate new, longer and wider electric trains in the future.

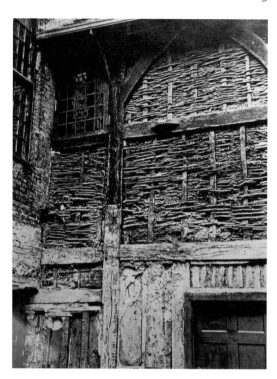

Astley Hall, Chorley. Timber building upgrade, 1950s.

Alexander Adie's 'Flying Arches' (1840s). This image was taken prior to their lifting.

2. Townscape Miscellany

Healey Nab

Growing up in Chorley during the 1940s, 1950s or 1960s meant that leisure times were spent in parks, recreation grounds or exploring the high ground east of the town called Healey Nab. It was referred to as being the place where one could go to get a breath of fresh air, for it rises 300 feet above the town. From the top, we could see the Lake District and Welsh mountains, Blackpool Tower, Southport and even a glitter of the Irish Sea on the western horizon.

Access was usually via Crosse Hall Lane, passing Mr Rennie's 1780s canal aqueduct, one of Chorley's lesser-known architectural features, which has become unseen due to tree growth. When 'up the Nab' one of the absolute must-do things was to partake of one of the best drinks of water in the area at the Nab Spout. Our parents insisted you took a bottle with you and returned with it full of water from the spring, where they had also drank from as children – a practice that continues to this day.

When the M61 was being built, a new quarry was opened and a large amount of stone removed. The top of the Nab was not altered, however, as stone was mostly taken from the quarry on the Chorley side of the hill.

Starting to the south in Anderton, the building of what is now Rivington Services saw minimal change to the landscape. A bridge was built over Crosse Hall Lane and Johnny's Brow north from this point. The former Rush Pit, a favourite paddling place close to Crosse Hall Farm, was filled in and the water from the Chorley Waterworks, higher up the hill, was piped into Black Brook.

I stayed in this area, at White House Farm, during school holidays and weekends, helping with farm jobs – we still used horses for light fieldwork and an old Fordson tractor for ploughing. At harvest time, a gang of travelling men came with the threshing machine and caravan, pulled by a steam-traction engine. Theshing was done in the cornfield alongside Watermans Cottage. Threshing time was busy yet enjoyable; the men told stories of their travels as we ate our usual cheese and pickle 'baggin' (sandwiches) and drunk our tea – forgive the nostalgia trip!

I sometimes helped out at either Crosse Hall Farm or Crosse Hall Mill Farm. Most jobs were related to milking and cleaning out, depending on the seasons, and I even learnt a little history along the way. Crosse Hall Mill Farm had been a watermill on the Crosse family's fifteenth-century estate. Some of the machinery that was used in the mill's later years (when it became a logwood-crushing mill) was, according to the farmer, 'under the shippon floor'. Prior to its demolition in *c.* 2010, I requested the developers allow me to undertake an excavation of the waterwheel pit and search for this machinery. It was refused. We could have had the wheel pit and some visible remains of that ancient mill retained as a historical feature. All I could do was sketch, photograph and watch the destruction of this historical site.

Rennie's 1780s canal aqueduct, Crosse Hall Lane.

Healey Nab. The lane to Chorley's former waterworks.

The Chorley waterworks' former site entrance.

DID YOU KNOW ?

Chorley Grammar School was established in 1611 by funding from local families. In 1648, Parliamentarians also donated money to the school, as did Cromwell's soldiers.

Healey Nab and its environs has seen many changes since the fifteenth century, such as a large-scale quarry working at Grey Heights from the sixteenth to nineteenth centuries. The Nab has seen the building of a town waterworks and supply reservoir (High Bullough), along with a header reservoir and filter beds in the nineteenth century, a bleachworks and ponds at Lower Healey in the twentieth century, and the motorway quarry in the 1960s. The 1798 Lancaster Canal runs north–south through the Black Brook Valley, which was joined to the north of Chorley by the Leeds–Liverpool Canal in 1816. Also in this valley is the Black Brook itself, Thirlemere Aqueduct, a major gas pipeline, and the M61 motorway.

The M61
The new 'M' road from the south continued north over Froom Street via the former the works yard of Lower Healey's bleachworks, which survived until the 1930s. During

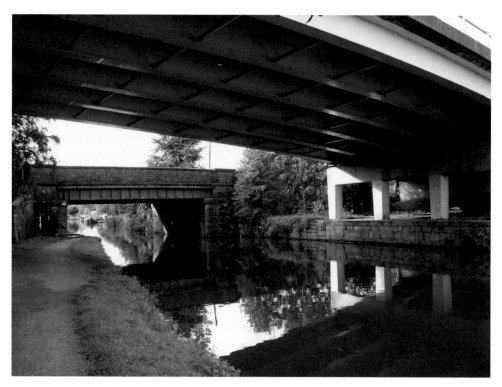

Botany Bay canal basin, with its old and new road bridges.

the war years and after the site was an army prison glasshouse. Continuing north, the new motor road veered to the north-west towards Botany, just by Talbot Mill. It was due to this slight change of direction that we lost a seventeenth-century hall, which had even earlier associations. This was Bagganley Hall, former home to the Parkers, who had connections with the former Royal Forest of Healey.

A new bridge over the canal was necessary beyond Bagganley Lane. From here to Botany, the canal and M61 run side by side. At Botany, a canal wharf and nineteenth-century warehouse were an essential part of Botany Bay, but were demolished to accommodate the new 'A' road bridge over the M61 and canal for the Chorley to Blackburn road. The old road bridge was retained but is no longer a through road.

A large area of land was cleared of houses between Botany Brow and the former Blackburn to Wigan railway line, which crossed the canal valley over a six-arch viaduct (built in 1868). This viaduct was also demolished to make way for the motorway; one wet Sunday morning the viaduct was cleared by explosives, while a large crowd of onlookers watched the demise of one of the town's great historical and architectural features.

'Up-Step' Houses, Statues and Memorials

Chorley's roots lie firmly with its industrial past, although, due to its rural setting, many farms have contributed to its developing need for foodstuffs and market produce. Until the coming of the cottage industry, there was little work available locally. The cottage

industry consisted of cotton spinning and some weaving in the cellars of houses, where damp environmental conditions helped to keep the thread supple.

Rows of cellared terraced cottages were built with windows at ground level outside to allow light to enter the cellar below – the working area. Steps in front of the cottage led up to the living area, or down to the cellar. These 'up-step' houses were located at Botany Brow, Parker Street, Chapel Street, Fleet Street, Cheapside, Anderton Street, Albion Street, Bolton Street and King Street. The best examples were at Botany Brow, although they were demolished to allow for road widening. Two rows of these unique houses survive: in Parker Street and in Chapel Street, the latter being covered by excess advertising signage and paint, which hides the character of the buildings.

The Fleet Street area, which has been a car park for some years, was the site of many of these cellar houses. The site was cleared for development in July 2017, during which time an archaeological evaluation was carried out to verify the presence of cellars.

Local on-site demolition losses have included the former St John's Ambulance Hall, a place where people attended weekly dances on a superb sprung floor, and the 1840s Primrose Cottage.

The 'Primrose' name reminds me of recent events, when a certain statue was removed from the top of a building it had stood upon for many years due to claims that the building was unsafe to support it. The statue – the only one in town – was of Mr Disraeli, a former British prime minister and a supporter of the Primrose League. Instead of being relocated to some fitting civic location, the statue has ended up as a garden feature

Cellar houses on Parker Street.

in the walled garden at Astley Hall. The Disraeli statue was one of the interesting aspects of Chapel Street. Annually, each Primrose Day, a wreath of primroses were placed on it by supporters of the Primrose League.

A new statue of a First World War soldier, representing the Chorley Pals, has been erected on the marketplace car park and civic offices, and has unofficially become a second cenotaph. I heartily agree with many other townsfolk that the statue itself, plus its name list, plinth and whole appearance is a great piece of work. However, many people disapprove of its location, having parades/ceremonies by it, or placing wreaths and poppies on it.

We have had a town cenotaph since the 1920s, but perhaps those concerned with its location are unaware that it is within the biggest war memorials in the whole of Lancashire. The whole of Astley Park is the town's war memorial, not just the area where the cenotaph stands. The park was donated to the townspeople of Chorley, along with Astley Hall, to become, the Chorley war memorial.

Markets, Mansions and Mills

Market Street was at one time our marketplace and had a town market cross. It is quite possible that we will see history repeat itself when we lose some of our Flat Iron Marketplace and the market returns to where it started from a few centuries ago. The land that the covered market is now on was given to the people of the town by the Gillibrand-Fazackerley family, along with a set of semicircular stone slabs – like stalls – with a lower front edge kerb so that nothing would slide off them. They were designated 'fish stones'. To commemorate the gift of land for the market, a street leading to the marketplace was named in honour of the Gillibrand-Fazackerley family

The family lived at Gillibrand Hall and had history going back to the fourteenth century. The early hall was built with a moat around it, but the building there today was constructed during the nineteenth century. The family's estates were extensive and their coat of arms, which has crossed swords, is visible on Cross Swords Farm in Cross Swords Close, off Moor Road.

Another former mansion can be reached by descending into Chorley Bottoms – down the steep Church Brow into Water Street, with Hollinshead Street to the right. At the beginning of Hollinshed Street is a section of wall that is crenelated, and in the centre of this section of wall is a studded door. This decorative archway was a means of access to the parish church by the Chorley family of Chorley Hall, along with other notables who lived to the north of the church. This work was one of the first local authority conservation projects in the pre-war years. Concrete supports/ties were attached between the ground and wall (inside, behind the door), which are now well overdue for restoration, before the old wall falls outwards.

Just past the studded door is Chorcliffe House, the main frontage of which is in Hollinshead Street. A gateway entrance leads to the rear of the house and the large garden (now built on). This garden was called 'the Dingle' and had a footpath across it some way from the house, which led to the Fellery, or Fellery Fields. Today, roughly in the same place, we have Fellery Street.

The former access to the parish church on Hollinshead Street.

Rear view of Chorcliffe House, Hollinshead Street.

The former Dingle stream was culverted to flow into the Chor in Water Street. After filling in the Dingle, the flat area above became the Flat Iron Marketplace. The name of the marketplace is thought to have come from the way stallholders placed flat irons on their goods to stop them from blowing away. The Flat Iron was also known as the Cattle Market – its animal pens were finally removed in the late 1950s.

The garden of Chorcliffe House was like an amphitheatre, with raised embankments and seating (when performances were held) around a flat centre lawn that the plays were performed on. The house itself dates from the eighteenth century and was the home of the Sylvester family, who were benefactors to the town and parish church. In the 1860s, one of the parish church's additional aisles was paid for by the family.

Other residents of Hollinshead Street, and benefactors to the town, were the Hollinshead family, who had a town house here away from their home at Tockholes and Hollinshead Hall. Mr J. Hollinshead supplied the necessary funds to build the first Town Hall in Chorley in 1802. Showman entrepreneur Mr Testo Sante also lived in the street.

Water Street was the only main road through Chorley until 1822, when Park Road was opened. This work had entailed the culverting of the River Chor from Water Street into Astley Park to allow the large embankment carrying Park Road to be built. Until Park Road was made, the River Chor was an open stream flowing along Water Street into the 'east lea' estate lands of the Charnocks of Charnock. Until 1822, all horse and vehicle movements along Water Street necessitated crossing the River Chor through a ford.

Returning to the front of the parish church, across the road is a former bank still retaining its cornucopia ('horn of plenty') plasterwork on the front of the building that was previously cottages called Terrace Mount. The former home of the churchwardens lies next to the White Hart pub, along with St Laurences Lodge, the home of the Pollards.

The first town gasworks were built in Water Street in the 1820s. These followed on from 1816, when coal gas was produced by one of the Lightoller Mills in Standish Street. The amount of gas produced was in excess of what was needed to light the mill, so the adjoining Standish Street was gas lit for a time.

A series of steps still leads from Water Street to the Nonconformist Park Street chapel, which was sponsored by Abraham Crompton. Crompton had purchased the Chorley family's hall and estates in the 1730s.

A Railway for Chorley

The railway arrived in Chorley in the 1840s, having been held up by the construction of the Black Brook Viaduct near Yarrow Bridge. The railway had a temporary station at Rawlinson Lane in Heath Charnock. There was a coaching service to Chorley until 1842, when Black Brook viaduct was completed and the station was built in Railway Street. Since that time industry connected with the railway started up, as did several foundries and engineering works. Mining was carried out in the town at several pits, such as in Steeley Lane, Clifford Street, Cunliffe Street, the Rangletts area and Moor Road

During the eighteenth century on Eaves Lane, where early mills had been built, the first housing here was stone cottages, with some used for quarrymen, canal and agricultural workers.

Botany Mill

The town's nineteenth-century cotton mills have mostly been demolished, but one of them – and a four-storey one at that – still exists and has a new role in the community. It is known as Botany Bay and is always busy. This former cotton-spinning mill was originally run by Messrs Widdows and Co., but is now a popular complex of stores, shops, a garden centre, cafés and children's facilities, with lifts to all floors.

The name of Botany Bay is taken from the adjacent canal, which had a wharf and warehouse a short way south of the mill building. This was the real Botany Bay, as well as Chorley's 'port'. As to whether the name was taken from the Australian penal colony of that name, I cannot say, but people say that the employees at the old canal wharf and warehouse worked as hard as the convicts 'at that other place'.

A Town Hall

The town centre got its first Town Hall in 1802 by benefactor Mr Hollinshead of Hollinshead Hall. The building was to provide a meeting place for the town's vestry and commissioners. It was erected in stone near the corner of the original Union Street, directly opposite Mealhouse Lane. The building also accommodated a couple of cells for criminals of the day. A special feature of this Town Hall was that it had a clock with outward visible dial, plus a bell that struck the hour. This bell was struck by a clapper in the shape of a ram's head. Because of this feature, the clock was referred to as being 'th'owd tup' in our Lancashire dialect, in other words, 'the old ram'.

St Thomas's Road to Southport Road

During the early nineteenth century, Market Street was wide enough for carts to pass in different directions. The new (1802) Town Hall was built at the corner of Union Street on the same line as the old seventeenth-century Royal Oak pub. This was opposite the Gillibrand Arms, at the corner of what would become St Thomas's Road.

Along St Thomas's Road, some houses and pubs had developed close by Town Green (todays St Thomas's or Town Hall Square), which was at the back of the Gillibrand Arms. The Green was at one time used for festivities and markets and had its own obelisk, where sales were held and public whippings took place – one well-recorded example tells us of a wife being sold here! Even marriages were performed by the obelisk.

Several inns were built around the Town Green – note the former stable and coach house behind today's Rose and Crown. Just past the former Town Green (later Town Hall Square), a random stone building stands on the corner of the current Devonshire Road. This building was owned by the Gillibrand family of Gillibrand Hall (also referred to as Lower Chorley Hall) and used as an office where officials of the family met and collected rents from their tenants.

No evidence was found to date the building's origin during my research. It could be that the old building is of sixteenth-century origin, and may have been a farmhouse during its 'first life'. Today, it is called the Manor House. A reminder of the family connection can still be found inside the building in the form of a crossed swords emblem in stained glass. The internal wall timber framing is also present in the building today.

A waterwork was established in Dole Lane, on a site that over time included a cotton mill, a foundry, and then a corn mill.

Above: Former coach house and stable, Dole Lane.

Right: The Gillibrand family coat of arms.

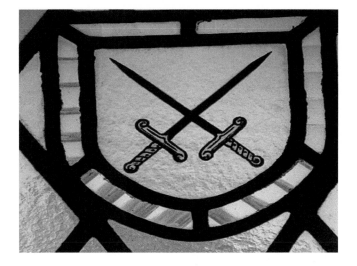

After passing the police station in St Thomas's Road, Devonshire Road is to the left and Crown Street to the right, leading to Queens Road. This is the site of the first purpose-built grammar school, which remained here from the 1860s until its closure in 1906. It was superseded by the technical school (now the library).

Properties off St Thomas's Road and Southport Road were only developed from the late nineteenth century; branching roads were also developed here, such as

Victorian houses on
Southport Road.

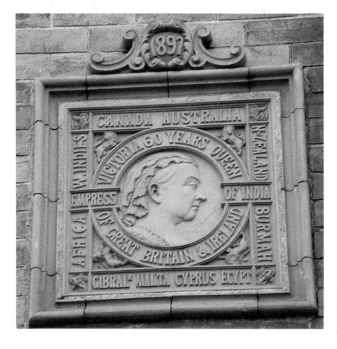

A wall plaque dating from
Queen Victoria's Diamond
Jubilee, 1897.

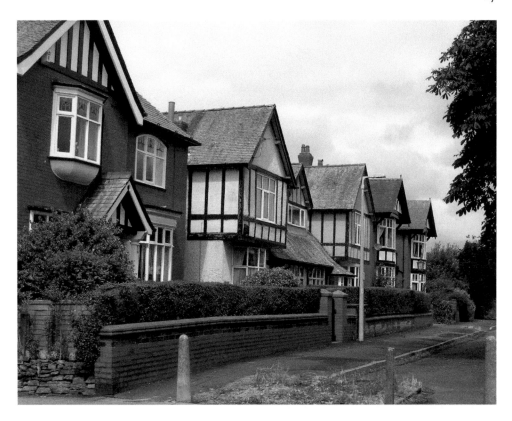

Above: Edwardian houses on Windsor Road.

Right: A 1902 wall plaque dating from Edward VII's coronation.

Bank Street, Ashfield Road (where six almshouses can be seen), Windsor Road, Balcarres Road and Sandringham Road. This area contains houses from the late Victorian and Edwardian periods; many still retain their original names on the gateposts, as well as former coach houses and stables. A number of houses from 1902 were built on the west side of Windsor Road so that their rear views were to the coast.

Gillibrand Estate

The south end of Windsor Road leads through what was once termed the Gillibrand Estate, where the Gillibrand family lived in their once-moated hall in the sixteenth century. The hall, which was rebuilt in the eighteenth century, still stands today as does a former stone barn with stables, close to where the 'home farm' was. It features the Gillibrand family's crossed swords coat of arms and a 1669 date. The sandstone barn has many interesting mason's marks to see.

The Gillibrand Walks Gate Arch was removed and re-erected at the front of Astley Park in 1922, when Astley Park became the town's war memorial.

Close to Tootall Street was the last cotton mill to be built in Chorley. Made in 1914, it was later run by local rugby hero Mr Bill Beaumont, whose family had a longstanding association with the local cotton trade.

Tootall Street ends at Moor Road traffic lights. In the eighteenth century, all of this area was still an open moor, with a road to Chorley heading one way and one to Coppull and Wigan the other way. The early houses here belonged to the Gillibrand family. There was coal mining activity in this area during the nineteenth century at Chorley Colliery, usually called Moor Pit, which was the last working mine in Chorley.

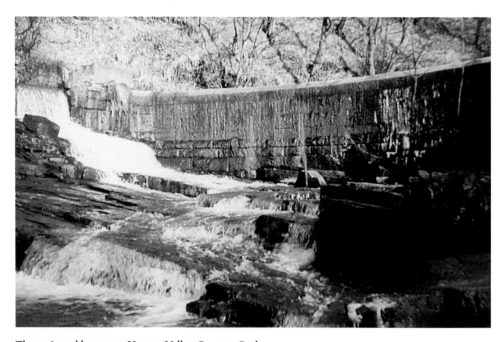

The weir and bypass at Yarrow Valley Country Park.

Weldbank to Burgh and Birkacre

Across from Tootal Street is Weldbank Lane. A short way down the lane, at Weldbank (so-called due to the land formerly belonging to the Weld family), is the entrance to St Gregory's RC Church. It is the highest church in Chorley and well worth a visit.

After leaving the churchyard gates at Weldbank, a left turn would take us down Burgh Lane, which leads to Lower and Higher Burgh Hall's. The Lower Hall still stands and is of a timber-frame construction dating from the sixteenth century. The Higher Burgh Hall was demolished some years ago. The de Burgh family are mentioned as far back as the fourteenth century. The name 'Burgh' is reputed to indicate a 'fortified place'.

Close to the area of Burgh is Birkacre, where today we have Yarrow Valley Country Park, created from a former bleachworks and coal mining area. It was here that Richard Arkwright started his first local water-powered spinning mill in 1770, which was burned down by rioters in 1779.

Pilling Lane and Carr Lane to Yarrow Bridge

Turning right as you exit the church gates take you into Pilling Lane. After this, turn to the right and into Carr Lane, which runs south-east to join the A6 at Yarrow Bridge. This section of road was opened in 1822 to supersede the original turnpike road from Bolton to bridge the River Yarrow, where the original Yarrow Bridge Inn was situated

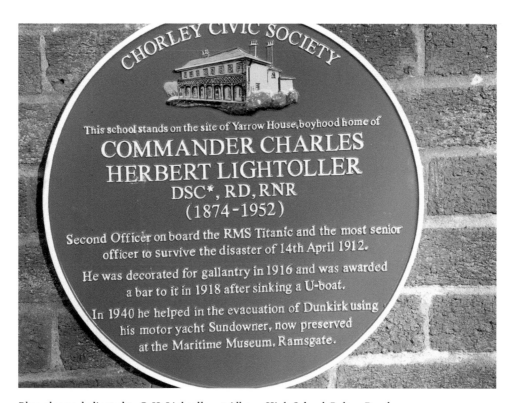

Blue plaque dedicated to C. H. Lightoller at Albany High School, Bolton Road.

Halliwells Farm, Bolton Road, Yarrow Gate.

downstream of today's bridge. This inn was made famous by Thomas De Quincy when he was writing his book *The Confessions of an Opium Eater*.

At Yarrow Bridge turn left to return up the hill towards Chorley town, approaching Albany High School to the right. Cross the road to find an ivy-covered wall with a set of gateposts. This was the entrance to Yarrow House that was built in the colonial style with a first-floor veranda across the front. It was demolished in the 1950s and the school was built later on the site.

The house was formerly the home of the Lightoller family, who were highly involved with the running of the first steam-powered spinning mills in Chorley from the 1790s. The Lightoller name is better known today due to the sinking of the *Titanic* in 1912; the senior surviving officer aboard the ship was Charles Herbert Lightoller, who was played by the actor Kenneth More in the film *A Night to Remember*. Charles Herbert was born at Yarrow House and went to school in Chorley's old grammar school in Queens Road before he left for a career at sea. A plaque noting his birthplace is on a pillar at the school's gate.

Continuing up the hill and back into Chorley we come to Yarrow Gate, which has an interesting seventeenth-century farmhouse known as Halliwells at the end of this cul-de-sac. Behind this old farm is the railway line from Chorley to Bolton and, passing under an 1840s railway bridge, you arrive at Yarrow Mill. Chorley's last remaining trio of mill buildings can be seen here clustered at the chimney base – a mill chimney, a boiler house and the former mill engine house. If you then return along Yarrow Gate to Bolton Road and turn right up the hill, you'll return to Chorley town – note the first row of terraced houses to the left at the top of the hill.

Steam-driven Mill Engine

The large Leyland Motors Group works site was located behind the row of terraced houses at the top of the hill. The site was open land until around 1910, when a new cotton mill was built that was intended for weaving. The mill was fitted with boilers and an engine, then put up for lease to cotton manufacturers to install their machinery. With the outbreak of war in 1914, the mill was taken over by the Leyland Motors Group, who started to produce vehicles for wartime use. The company were in business here until the late twentieth century. The mill was never used for weaving.

During its later years I was allowed to visit the site, which still had in situ a steam engine to turn the engine by hand, ensuring its freedom of movement despite being highly greased. The engine was still in good condition. Its future preservation was a concern among many groups and organisations. One proposal was that it be moved to Birkacre, where it could be displayed outside as a static exhibit; however, this suggestion was dismissed due to the engine being in good condition and in running order, lacking steam only.

Due to pressure for the site to be cleared, the engine house was demolished around the steam engine, which was taken down by members of the Bolton Mill Engine Society for Chorley Council to store securely. Unfortunately, many of the engine parts were stolen while it was in storage and the larger, now rusting, parts were then given away by the local authority. During this frustrating time trying to safeguard the engine's future in Chorley, I met with two local businesses who agreed to accommodate it on their premises if I could organise its rebuild. This was not possible at the time.

The Big Lamp Area and Fleet Street

To the left of Pall Mall junction is the Asda car park, a site previously occupied by offices and a Co-op storage building. The junction here was illuminated from the nineteenth

Chorley Moor Weeping Cross replica, Fleet Street/Cheapside.

century by a cast-iron decorative lamp standard called 'the Big Lamp'. It was gas lit until the 1950s and then removed, though it could have been converted to electricity.

Close to the Pall Mall corner is Fleet Street where, a few yards along, is a small grassy sitting area at Cheapside that has a stone obelisk on a plinth. The stone and plinth for this was sourced and made by Mr S. Whalley and myself to replace the former ancient Chorley Moor Weeping Cross, which was lost due to road widening in the nineteenth century.

Cheapside and Market Street

Back in Market Street – our main thoroughfare – and our 1879 Town Hall is in sight. Gillibrand Street is to the left and a short way up it is Chorley's first hospital. It was built at the expense of Mr Rawcliffe and has now returned to use as a local surgery. If you continue along Market Street, you'll see an arch to the left that leads to St Mary's Church. It is there to commemorate the long period of service by the late Canon Crank.

Across from the Town Hall is the former Odeon cinema of 1938, now used by Gala Bingo. At my request, I recently toured and photographed the inside of this former cinema. It was good to see that art deco features on the doors, plasterwork and lighting was still in place.

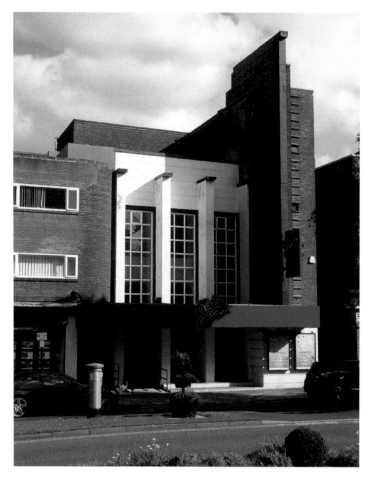

The art deco frontage of Chorley's former Odeon cinema, Market Street.

The Odeon's art deco wall plasterwork in the foyer.

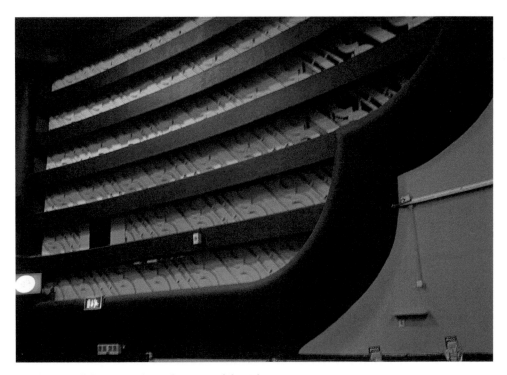

A lighting wall feature in the auditorium of the Odeon.

3. Building Features

Vernacular Buildings

I am aware that there are a great variety of features to see in the Chorley area – in the town and in the surrounding twenty-three villages – but I've decided to start this chapter with some at Duxbury Park, the home to our municipal golf club and the site of Duxbury Hall.

Duxbury Hall comprised the manor house and parkland as part of the wider estate of the Duxbury family in the thirteenth century, and later the Standish family. The site has long been associated as the birthplace of the famed Myles Standish, who sailed with the Pilgrim Fathers to the New World.

In one of the enclosed walled areas, we have a magnificent cruck barn – this was all original until it was agreed to be used as office premises by the local authority. A cruck building is one that utilises a curved tree trunk and/or a curved branch of suitable thickness that is sawn down its length to produce two identical curved frames. The pair of frames are then joined together at the top with a cross tie beam halfway down to form an 'A' shape. Fortunately, in the Chorley area we have barns of this type in Rivington, Euxton, Heskin, but only one in Chorley itself. At least two of these buildings has been lost from the town: at Clayton Hall and Chorley Hall.

There was also a row of cottages in Crosse Hall that were cruck built. Perhaps, the best known local cruck barns are the two at Rivington: Hall Barn (Top Barn) and Great House Barn (Bottom Barn), which are always well patronised for recreation and cafeteria. Inside either of these two barns you can see how the timber frames are joined and how the bottom end of the great cruck frames are placed on large stones called stylobats, which prevent the lower end of the frame from getting damp.

The date of the cruck barn on the Duxbury Hall site has, to my knowledge, never been dated by dendrochronology. But as it is similar to other local examples, it is likely to be of fifteenth- or sixteenth-century origin. It could even be earlier than this as the site has associations with the Standish family from fourteenth to fifteenth centuries, and before this the Dokesbury family were here after having moved from the local moated site at Bretters Farm in the thirteenth century.

While at Duxbury Hall, it is worthwhile looking at the garden features to the west side of the golfing complex and café area to see the extensive stone-built grottos. One of these had steps leading down to the River Yarrow, where there was a gravestone to a dog named Beavis who belonged to the residents at the Hall. One night Beavis's barking woke everyone and alerted them to a fire; it was quickly put out and everyone was unhurt. Beavis's statue was stolen some years ago.

Sadly Duxbury Hall was demolished in the 1950s, but its yard and surrounding buildings are still of interest. The Hall would have been of timber construction in its

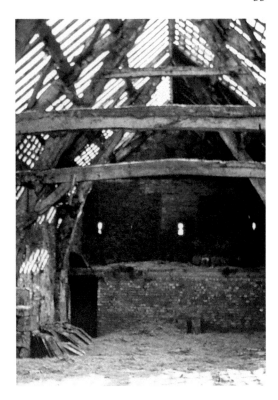

Right: A local cruck barn, similar to Duxbury Barn.

Below: Shelters and grottos in Duxbury Hall's gardens.

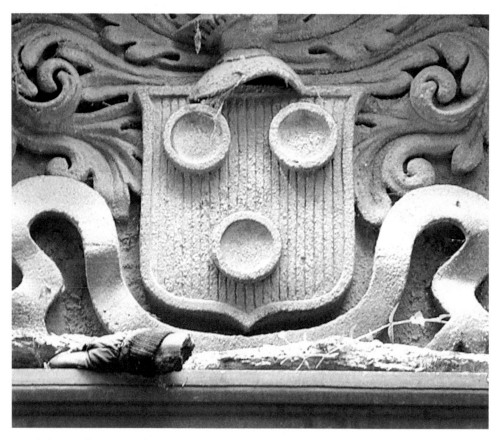

Standish coat of arms in pediment on the gatehouse at Duxbury Hall Park gate lodge.

earliest years, but after several rebuilds stone was eventually used for its construction. We do have another local timber-framed hall, however, Buckshaw Hall, which was built in the seventeenth century.

After leaving Duxbury Park, passing the classical gate lodge onto Bolton Road, notice the three tun dishes on the Standish coat of arms in the pediment above the supporting columns.

Hoggs Lane

Around 300 yards along, Hoggs Lane was the site of what was once the second of Chorley's spas, where visitors came to 'take the waters'. The well spring was discovered while trial borings for a mine was being carried out. The building alongside the lane was part of the spa hotel complex.

Further along, Hoggs Lane is the magnificent Black Brook railway viaduct, which carries the Bolton–Preston railway and was built in the 1840s. It is soon to be fitted with pylons for the overhead electricity wires. Passing under the viaduct, there is a triangular area of open land that adjoins the canal. There was a canal wharf here that allowed boats to offload materials for the building of the railway viaduct. The navvies also lived on the site.

'Tinklers Barracks'

A row of houses was built here and the area had the nickname Tinklers Barracks; whether or not it is so-named because someone with the surname Tinker of lived here is not known. The likeliest story I have come across is that the name should actually be Tinkers, as apparently the site was once a favourite stopping off place for travellers or 'tinkers'. The canal bridge here used to be the main route from Cowling Road via Hoggs Lane to Bolton Road.

If you return down Hoggs Lane to Bolton Road and then turn right, you will walk uphill into Chorley.

Preserved Cotton Mill Chimney

Continue along Bolton Road and you'll find the town's first large roundabout. Nearby, to the right, is a former mill chimney that is well over 100 feet tall. When a Morrisons supermarket was built here in the 1990s, this chimney was incorporated into the complex. The chimney is Grade II listed due to its stone 'oversailer' coping stones and its iron strap banding and ties. The chimney, at this former Victoria Mill site, has survived two major mill fires. It was saved due its association with the cotton spinning and weaving – Chorley's former primary trade.

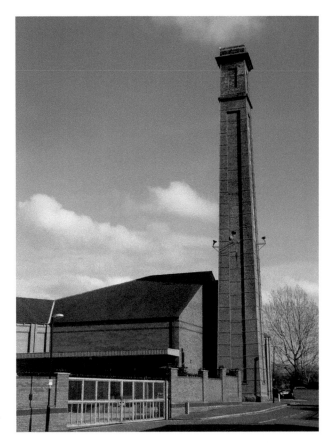

Preserved Victoria Mill chimney, Lyons Lane.

Continue down Bolton Street to arrive at the Pall Mall/Market Street junction. This area has long been nicknamed the 'Big Lamp' due to a large lamp having been sited here from the 1860s, on top of a small plinth in the middle of this three-road junction. Unfortunately the original was lost to us for around forty years, that is until a local benefactor donated money for a replacement lamp. The new one was undecorated and lightweight, unlike the original, but at least we had another 'big lamp' for the area.

During the 1990s, a road-widening scheme necessitated the removal of the lamp once again. It was also during this time that the corner of the Pall Mall Triangle was redeveloped to have 'a grand building to balance this end of Market Street with the Town Hall, at the other end of the street'. However that 'grand building' never appeared. A simple building of steel and brick –with little character – appeared instead, built as a 'major' office centre and store for the Co-op. That was not to last, though, as it later became a general store for another few years. It was in use for ten to twelve years in total; we now have an Asda store on the site with a very large car park. The reason for this huge parking area is that the full proposed development has not been carried out ... yet!

Pall Mall Triangle

On this corner of Bolton Street, Market Street and Pall Mall stood the former St George's School, a National School built in the 1820s. This corner block once accommodated the town fire station, a slaughterhouse in Back Street and the school. The school building had a bell enclosed within a turret and a date stone below that was worthy of saving when the main school was demolished. It was eventually agreed that the bell turret would be incorporated into a proposed new building close to Pall Mall. The building was never built and the bell, stone turret and datestone did not return either. Recently, in spring 2017, the bell arrived back on the site, but without the stone turret surround or date stone feature that had been saved when the school was demolished. This isolated bell now has a short descriptive plaque some distance away from it; sadly, from observation, I have noted that people do not seem to associate the two items as they are too far apart. It remains uncertain as to where the preserved turret stones are today.

DID YOU KNOW ?

Oswald Mosley of the Blackshirts movement gave a talk in Chorley Town Hall in the 1930s, as did his famous henchman Richard Joyce, who became known as Lord Haw Haw on the radio programme *Germany Calling* during the war years.

The building on the corner of Cheapside and Market Street was part of the former tenants' extension while it was occupied by the local Runshaw College. At the front of the building, the ground-floor Market Street frontage has been altered. It had started life as the local Lancashire Electric Power Co. offices and showrooms, referred to as the LEP.

If you walk across the street and look back to the building, elements of 1920s/1930s art deco styling can be seen in its upper-floor architecture. We have very little of this style of building feature in Chorley; two other examples include the former Woolworths and Odeon buildings.

Gillibrand Street to the High Street

Gillibrand Street extends to the west onto land formerly owned by the Gillibrand family. Chorley's first hospital, funded by Mr Rawcliffe, is located along here. Coronation Recreation Ground, opened in 1913 by George V and Queen Mary, is at the far end of the street. Also noteworthy is Parsons Brow, which is where visiting clergy would stay at a large house run by local churches.

St Georges Street is an obvious route to note, with its church tower sitting cat-like overlooking the street. A former Baptist chapel once stood in this street, though it is now demolished. The street also had a Reform Club, which has now been converted to domestic accommodation.

Opposite St Georges Street is Peter Street. This led to the back of the hospital mentioned earlier. The old carriage driveway and gates can still be seen. There was once a long work shed on this location that extended towards Devonshire Road – a former ropeworks from the nineteenth century until the 1960s, but there is little information available about the business.

Frontage of the first town hospital, Gillibrand Street.

Opposite a large archway on Market Street that leads to St Mary's RC Church, you'll find Chapel Street, which leads to Cleveland Street and the covered market area. There is some wavy brickwork here that joins with more at the corner of the two streets and continues around a big-toothed cog wheel and extends along Cleveland and Chapel Street.

When turning into Cleveland Street, note a remaining former coal cellar cover, located before Back Fazackerley Street. Continue along Cleveland Street and you'll see cobbles in an elaborate open-fan pattern, which are currently in dire need of restoration due to excavation damage. The town's coat of arms are laid on the ground close to the market toilet block and there is adjoining bronze artwork on the wall of the building. Have you read the information plaque? This bronze artwork is called *The Pattern of Life* and has a number of sponsors listed. Opposite this work of art is Fazackerley Street, named after the Hawarden-Fazackerley family (Gillibrand) who donated the land to be used for a marketplace.

Continue along Cleveland Street to arrive at the corner of High Street. To the left is the back of the Royal Oak building. This was – until perhaps the early 1960s – the place where all the main official functions of the town took place, even taking preference to the Town Hall function room, whose acoustics were poor. Sadly this once prestigious pub/hotel in Chorley town centre has been used less and less, which led to the building being converted into shop and office units during the 1980s and 1990s.

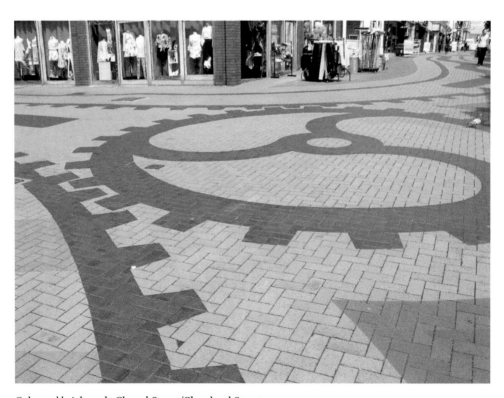

Coloured brickwork, Chapel Street/Cleveland Street.

Right: Chorley coat of arms, Cleveland Street.

Below: Bronze artwork on a building wall, Cleveland Street.

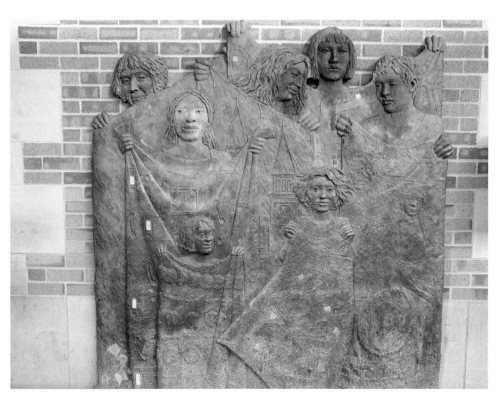

The present Royal Oak building dates from 1938, having been rebuilt further back from the old line of buildings in Market Street. At least two former pubs with the same name have been on this site; the original was one of three stagecoach inns likely to have been built in the seventeenth century.

During the war years, 'the Oak' was one of the popular town pubs that our semi-resident American Air Force guests used to favour – so much so that one of the pub's bars was given the nickname the American Bar, which went on to become official.

The Royal Oak building is soon to be demolished for a third time. Let's hope whatever replaces it in the future (after its period as a car park) has a connection with the name of the site and the town's history – perhaps the Royal Oak Hotel again with a commemorative oak tree being planted.

The former Market Tavern pub on High Street, where local farmers and visitors would meet on market day, has recently not only changed its name to the Flat Iron – creating confusion with our market site – but the pub has also removed its Georgian windows, along with its character.

High Street to Union Street

At the bottom of High Street, by the junction with Cleveland Street, look to the right and you will see a curved corner building. This was Chorley's first purpose-built post office. The post initially arrived in Chorley by stagecoach, which would then stop at an inn. Five other buildings have also been used for our latest bookshop/post office.

Former 1920s post office on the corner of High Street.

Above: Terracotta date stone on Union Street Technical College.

Right: Animal statuary, Union Street Technical College.

Continue to the end of Cleveland Street, where it meets with Union Street. To the right is the present library building. This was Chorley's first technical school, which opened in 1906. A new school was built on Southport Road on land that was being used as playing fields; development is underway here once more, with further houses being built.

The red and yellow terracotta decoration makes the frontage of the Union Street building very striking. Following the relocation of the pupils to a new school, the building became a teacher training college for many years. The lower part of the building later became the Central Library and remains as such today; the upper floors are used by the Lancashire Education Committee.

Chorley's first Town Hall stood near the end of Union Street facing our present one. We had two Town Hall buildings between 1879 and c. 1930. The closure of the old Town Hall saw its butter market (used for the selling of general farm produce) transferred to the new building cellars with public access via Mealhouse Lane.

Optional Walks from Church Brow

Several different routes can be taken from the gates of St Laurence's Church. They can't all be covered here, but a brief mention of one option into Hollinshead Street and Water Street may be of interest.

Church Brow became a footpath following the widening of Park Road in the 1970s. Hollinshead Street joins Water Street at the bottom of the Brow, where the Sylvesters

Originally Terrace Mount, Park Road, later a bank with cornucopia logo.

lived here in Chorcliffe House – the Sylvesters also have a road named after them in the town.

The former Nos 1 and 3 Hollinshead Street, from the 1970s the Swan with Two Necks pub, is now derelict. Originally one of these houses was a doctor's residence, and they were built in the late eighteenth century.

A modern neo-Georgian building in Water Street – formerly the local tax offices – is now awaiting new tenants. The external design of the building was chosen so that it would reflect the Georgian styling of Chorcliffe House, which is located opposite in Hollinshead Street.

A short way along Water Street, there are some steps leading up to a small Nonconformist (now Unitarian) chapel with a manse and some preserved cellar houses in Park and Parker streets. This small chapel once had Bonnie Prince Charlie's men staying here, and its benefactor was Abraham Crompton, who purchased the Chorley family estate. It is also the place where a certain Revd Tate was preacher, whose son Henry Tate became well known in the sugar trade. The Tates lived opposite the parish church in Terrace Mount. Henry Tate, who was born in Chorley, is also famed for founding the Tate Gallery in London, renowned for its collection of British art, and international modern and contemporary art.

4. Churches and Chapels

Christianity arrived in Britain when it was introduced during the Roman occupation. At this time, more and more Romans were Christian in their beliefs. It is thought that during the later centuries of the occupation – likely the third and fourth century – is when Christianised Romans were first arriving in Britain. There is no archaeological evidence that these Christian Romans settled in Britain, but Christian images have been found on Roman coins that have been discovered here. The uncertainty around them, though, is whether they were brought into Britain from a European country or whether they were actually minted here.

The departure of the Roman garrisons and their commanders left the senior Romano-British officers to run the country; a country now outside the Roman Empire. It is believed that during this time more followers of the Christian faith came to Britain.

Some early events surrounding Christianity and this time are likely legends, especially some the fifth- and sixth-century saints' lives. Take, for example, the story of St Patrick: according to legend he was shipwrecked close to the shore Morecambe Bay around the time the Romans left Britain – true or false? There may some elements of truth to it as a chapel was built at Heysham before the tenth century and called St Patricks. This chapel also has a Viking grave marker from *c*. 900 called the Hogback Stone, which has now been moved inside the chapel for safekeeping. The chapel itself is pre-Norman, dating to around AD 1000. It was certainly revered, for a second chapel was built close by that is dedicated to St Peter (unfortunately in ruins today). There are also some graves cut into the rock of the cliff edge close by.

Place name evidence of pre-Norman Conquest churches exists in the form of the old British word 'ecles', which refers to a church. A local example is Eccleston; as 'tun' or 'ton' means 'field' or 'meadow', the name of Eccleston means 'church by the meadow'. There is another Eccleston in Merseyside, as well as an Eccles. There is an Eccleshill near Blackburn, and in the Wyre we have Great Eccleston.

The first religious houses were established from around AD 1000, but these were nothing like the later large monasteries. The arrival of the Normans saw an increase in religious houses being built. At the time of the Domesday survey in 1086, the area from the River Mersey to north of the River Duddon only had fifteen churches.

DID YOU KNOW ?

A poem exists relating Oliver Cromwell's alleged stay at Astley Hall, which starts: 'When Cromwell came to Chorley Town, in the fiery wake of Battle'.

Early Churches

Between the River Mersey and the River Ribble there were seven churches mentioned in Domesday – located at Blackburn, Leyland, Wigan, Winwick, Warrington, Walton and Childwall. There was an additional note by the commissioners that 'certain lands in Childwell and Leyland were held by priests'. The survey does not include churches already is existence at this time to the north of the River Ribble, nor are some of the pre-Conquest churches mentioned in areas such as Ormskirk, Sefton, Eccles or Prescott.

Although, seemingly, there were omissions to the survey undertaken for the 1086 report, the inspectors were told to find out about the lands and manors, who owed what, and how this came about. It was not specified in their remit that churches should be noted.

It appears that our previously mentioned Roger of Poitou, in his Lancaster Castle, was one of the first to request, in 1094, that a Normandy monastery send a group of monks to Lancaster to establish a local priory. In return for this favour, Roger gave the Benedictine Abbey of St Martin in Normandy land in Lancaster (estates in Lonsdale and Amounderness wapentakes), plus the income from several Lancashire churches.

A second notable event regarding the spread of early Christian teachings in Lancashire was when the Benedictine abbeys at Evesham and Durham inherited land in Lytham and Penwortham. In both cases, small 'cells' were established in the township. In 1319, St John's Priory in Pontefract established another 'cell' in Up Holland.

The Cistercian order favoured more isolated areas to build their monastic houses, such as at Furness and Whalley. The Augustinian order built four houses – one of these being Cartmel Priory. Another order, the Premonstratensians, built two houses: one at Hornby and the other at the isolated location of Cockersands. All of these religious houses were established during the twelfth and thirteenth centuries. Out of them all, there were just three that had dealings with our county. Local land around the Chorley district came under the control of Whalley Abbey.

St Laurence's Church

The oldest of Chorley's churches is the parish church of St Laurence. It is thought to have been established in Saxon times, when small religious groups were often established following the visit of a travelling priest.

The original stone tower – still present today – has the later addition of a Norman-style (Romanesque) west door arch built into it. It is particularly evident when examining the tower base and buttress stonework and its eroded faces. The original doorway, built at the same time as the tower, seems to have been removed during the 1860s. Note the eroded coats of arms and heads on the tower buttresses, and compare those features with the present doorway arch.

The truth is unclear, but it is recorded that by the thirteenth or fourteenth century Chorley came under the parish of Croston, and a small chapel was set up with visiting clergy from Croston. The Chorley churchgoers previously had to travel to the church at Croston – around 6 miles away.

By the mid-1350s, the people from Chorley petitioned the Lord of Croston to allow the town to have a separate church. This request was agreed to by Lord Croston, but

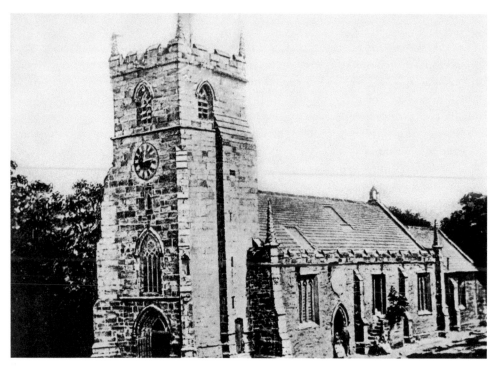

St Laurence's Church, pre-1860 – Chorley's parish church.

The time-eroded boar heads on the tower of St Laurence's Church.

the Lord of Chorley had to pay a fee to him in 1362 to acknowledge their agreement. However, despite this, Chorley was not yet completely independent: it still had to have a priest from Croston and the Lord of Croston remained the overall authority. It continued in this way for the next few centuries until, due to the intervention of the Chorley lordships and an Act of Parliament, Chorley became an independent chapel in 1793 and was thus allowed to have its own priest.

There is little surviving documentation about the church's early history in the area, but we do know that several emerging local families of note are associated with it – either in the form of baptisms or burials. Examples include the Chorleys of Chorley Hall, Gillibrands of Gillibrand (or Lower Chorley) Hall, the Standish family of Duxbury Hall (who were part of the Standishes of Standish Hall), the Charnocks of Charnock and Astley, the Brookes and the Silvesters among others. These families were all emerging from the thirteenth century and were variously the Lord of Chorley, with the Gillibrands being the final sole lords of the manor of Chorley.

One family name is well known to our local and national history due to his association with the Pilgrim Fathers: Myles Standish, who may have been born at Duxbury Hall. A branch of his family had lived there from the 1330s, away from the family home at Standish Hall. Before Myles's time, Sir Roland Standish, who fought at the Battle of Agincourt, gave to the parish church a skull purporting to be that of St Laurence – it was later removed substituted with other bones.

The Standish pew in the church is a wonderful example of early woodcarving. It has been moved from the chancel arch to the rear south aisle. A question often asked

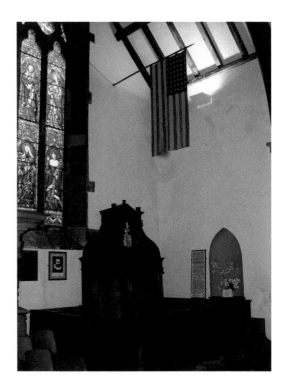

Chorley's parish church – the Standish family pew with the American flag above.

Left: St Laurence's Lodge – former churchwarden's house.

Below: Chorley's parish church today.

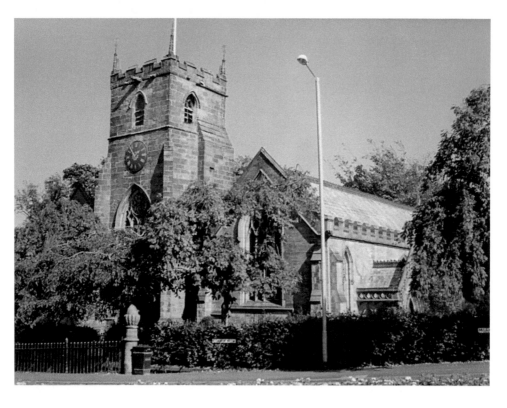

by visitors to the church is: 'Why is the USA flag above the pew?' The reason is the connection to Myles Standish, who sailed to the New World with the Pilgrim Fathers and went on to become the overseer/governor of the first British colony there – Duxbury.

St Laurence's Church is the burial place of several members of the Standish family, as well as the location for their baptisms. Myles Standish was allegedly baptised in the church, but the registry entry has been defaced and is illegible; it's thought this may have been done deliberately to remove his name and possibly his inheritance of the Standish estates.

It is for the association with the Standish family and the USA that visitors come to the church today. The flag above the seventeenth-century pew was presented to the church in 1943 by Commander Gayle of the USAAF servicemen, who were stationed in Chorley at Washington Hall. The flag was given to the church to commemorate the special affinity of Chorley's parish church, the Standish family and the founding of the British colony in the USA. There is a monument to Myles Standish in Duxbury, Massachusetts, USA.

I previously referred to Myles Standish's name being known nationally (internationally, too, with the USA connection). Even the poet Longfellow knew about Myles and wrote a poem called 'The Courtship of Myles Standish', which refers to Duxbury Hall.

Up until the late 1850s, the church building consisted of a tower with a central nave and an entrance at the south-west side close to external steps leading to the internal gallery. Two aisles were added in the 1860s and the original walls were replaced by columns.

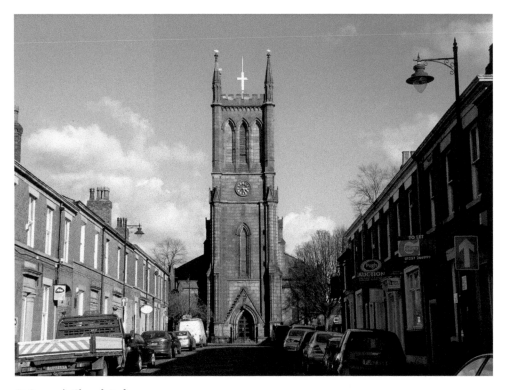

St George's Church today.

New Churches Needed

The growing town of Chorley in the eighteenth and nineteenth centuries saw additional churches built for various denominations. In 1782, a Congregational church was built in Hollinshead Street – it is now under threat of demolition due to the site being required for a car park. A Wesleyan Methodist chapel opened in Chapel Street in 1792, the first such chapel erected by the Wesleyans in the district that was used for public services. Another chapel on Park Road was opened in 1842, but is now closed. St George's Church was opened in 1825 when an additional parish and church was necessary due to a population increase. St George's was one of the so-called million-pound churches that was built with a tower but no clock. Its sub-church was St James's, which was built in 1878. The parish church of St Laurence also had a sub-church with St Peters, which was built in 1851.

There is quite a story connected to the Roman Catholic faith, which begins when a private chapel at Higher Burgh Hall, home of the Chadwicks, was first used for worship during the years of persecution. Land for a mission church was obtained from the Weld family, which was built in *c.* 1774 at Hodson's Farm, Weld Bank. The church is dedicated to St Gregory and was completed in 1813, with later additions. By 1847, the need for an additional church was necessary and as the former Wesleyan chapel in Chapel Street was now vacant, so it was purchased to accommodate the increasing congregation. Meanwhile, land close by, in an area known as Mount Pleasant, came under consideration for a new church to be built. This was on land formerly held by the Weld family but was

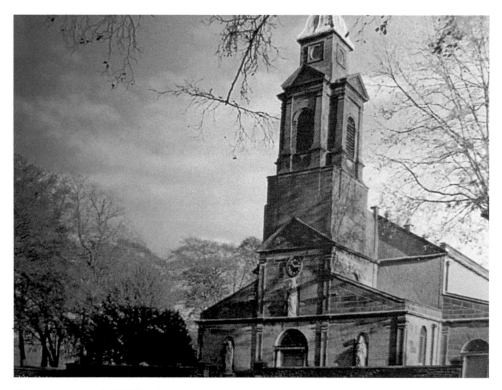

St Gregory's Church, Weldbank.

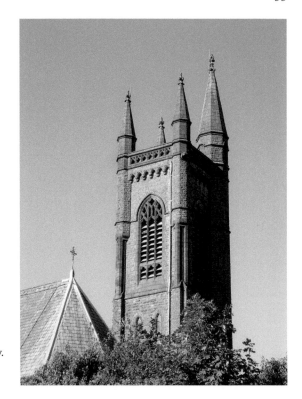

Right: St Mary's Church – Tower Trinity.

Below: Interior view of St Mary's.

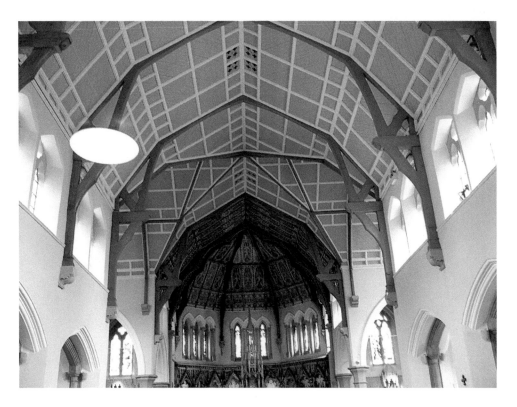

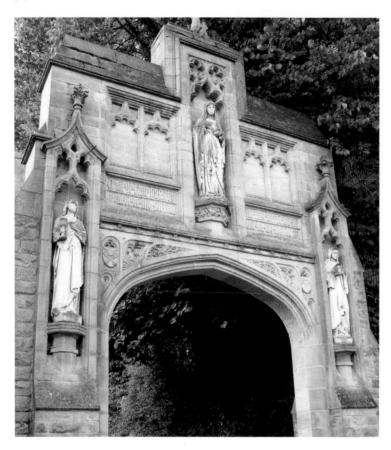

Commemorative arch at St Mary's.

then owned by the Harrisons. The land was bought in 1851 and St Mary's, the largest Roman Catholic church in Chorley, was built. Designed by John Hansom of hansom cab fame, it was opened in 1854 as a two-storey church with seating for some 800 persons.

In association with the church was a school (originally in the church itself) and a club with bowling green and also, unusually, an outside swimming pool – this was where today's car park meter is located behind the church building. The school has since been relocated some distance away from the church. The new club and bowling green were removed from their original site, but are still close by.

Around 1908, the interior of St Mary's was subjected to alterations. These were carried out by the eminent Victorian designers Messrs Pugin and Pugin, whose work is still appreciated and enjoyed today.

The arch at the Market Street entrance to Mount Pleasant and St Mary's Church was erected in 1912 to commemorate the long period of incumbency of Canon Crank. The former manse for the church was immediately to the left as one passes under the arch. I can recall one of the downspout head boxes had an eighteenth-century date on it, which suggests that the building was here well before the church was built.

That old manse was demolished and replaced by offices, and a new one was built to the rear of the church. The old building was likely to have been the home of the Harrison family.

The Bells of St Mary's

The tower at St Mary's Church is another of its grand features. Built in 1894, its distinctive four pinnacles – one large and three small – imply one God existing in three, aka the Trinity.

The bells in the tower were originally hung higher than they are today, but were lowered due to excess movement of the tower. During the 1950s and 1960s, St Mary's bells were used less frequently due to the demise of former elderly ringers. At the same time at St Laurence's Church, we had a band of young ringers 'learning the ropes' – I was one of them. Both sets of ringers decided to join forces, using alternate towers for weekly practice, so that the bells could be used at both towers. We also did joint maintenance in both belfries and even joined forces to ring at weddings occasionally. It is – or at least it was – possible to stand above St Mary's bells when they were all ringing. It's one very special sight to see and hear, for St Mary's harmonic bells are a treat to the ear, especially when you are ringing them.

An Iron Church

By the 1870s, a growing population meant there was a need for another Roman Catholic church to be built – in 1801 the population was 4,816 and by 1871 it had grown to 16,864. Plans were in motion to establish a church and school in Brooke Street. Arrangements were made to establish a 'mission church with school' on a site already agreed upon, so fundraising and the drawing up of plans soon began. The mission church and school building was built by two local contractors named Mr Browning and Mr Crook. The new mission church/school opened in May 1875.

After a few years, it became obvious that a separate church building was needed. It would be a temporary structure initially, until sufficient funding was to hand to build the new stone church. In 1878, a possible solution arose in the form of funds from a Father Carroll, who had learned that a church building in Manchester was vacant and up for sale. This was built with a wooden frame and corrugated-iron outer walls.

Following a visit to the Manchester church site, an agreement was made to purchase the disused church for a price of £500. However, due to the then bishop not being informed of the proposed temporary building that was to be built close to the existing mission, permission the build the so-called Iron Church was refused for a time.

Once again, it was due to Mr Towneley Parker's gift of land and a sum of money, plus his acquaintance with Cardinal Manning, that the temporary Iron Church was rebuilt after a month or so, during which time much of the timber frame was replaced. The church opened on 1 October 1878.

The Chorley proposal to build the stone church was the lowest tender at £8,483 and was accepted. The local builders were Messrs Leyland and Mawdesley. The contract was agreed in June 1894, followed by the blessing and laying of the foundation stone for the new church in August 1894. The new stone churchof the Sacred Heart, which replaced the temporary iron one, was prepared for opening in early October 1896. The opening was to coincide with the closure of the Iron Church, with a morning service in the old church and afternoon service in the new one on 18 October 1896.

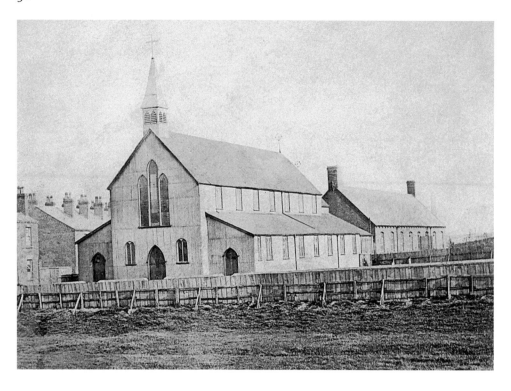

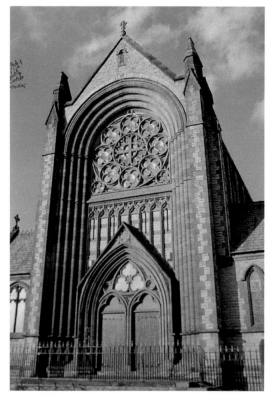

Above: Sacred Heart Roman Catholic Church – 'The Iron Church'.

Left: South front gable of today's Sacred Heart.

Foundation stone ceremony at Trinity Methodist Church.

Trinity Methodist Church and former school.

Methodists, Baptists and Later Churches

The growth of Methodism in Chorley is another interesting story. Its earliest beginnings are in the 1770s in Bolton Street, where a small house was used for group meetings. The movement was helped by mill owner Richard Smethurst of North Street Mills, who was benefactor to the first purpose-built chapel for the Methodist movement in Chorley. It had been built at the lower end of the street, which gave it its 'Chapel Street' name. The church was in use from 1790–1842, and was superseded by Park Road Methodist Church. The Chapel Street building was returned to use by the Roman Catholic church prior to the building of St Mary's.

Additional Methodist chapels were established in West Street (1859), Cunliffe Street (1866 – now the Masonic Hall), Railway Street (c. 1868 and demolished in 2017), Moor Road (1876), Heapey Road (1884), Trinity (1895) and Lyons Lane (1899). Two other chapels were on Eaves Lane: one at the top of Brooke Street, now converted into apartments, and the other further along Eaves Lane . The latter is now demolished but its porch still survives and was reused at the listed Coppull Ring Mill. There was another small chapel too, in Hill Street, but there is uncertainty as to its denomination.

The Baptist movement in the town began in Back Mount in 1802, with a second group meeting in an area called Holborn in a court off Market Street. This was close to Anderton Street, which is where the group relocated to before their first church was built in Chapel Street in 1848; it survives as Malcolm's Music Shop today. The Congregationalists had chapels in Hollinshead Street and St Georges Street.

Some of the twentieth-century churches in Chorley include St Joseph's RC Church on Harpers Lane, All Saints C of E Church on Moor Road, and St Anslem's, off Tootall Street.

Hollinshead Street Church frontage.

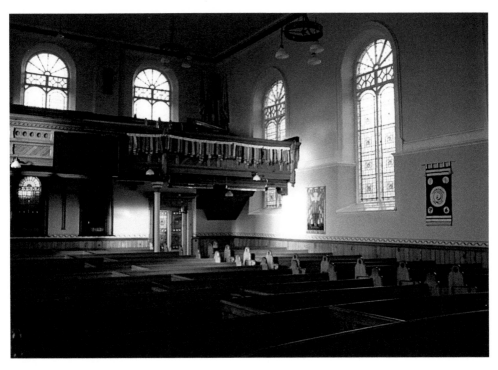

Hollinshead Street Church interior.

The foundation stone of St Joseph's was laid by Archbishop Whiteside in June 1909 and the building opened on 1 May 1910.

Park Street Chapel

Park Street Chapel is accessed from Water Street via a long flight of steps, at the top of which is the manse and church of Park Street Nonconformist (later Unitarian) Chapel. This small church was erected following the bequest of Mr Abraham Crompton, who was a banker in Derbyshire. His association with the town follows the execution of Richard Chorley (the last male heir of the family) at Preston in 1716. Richard's estates were confiscated and his wife left Chorley Hall to live out her life at Gillibrand Hall (also known as Lower Chorley Hall).

In the 1720s the Chorley estates were sold to Abraham Crompton, a Derbyshire banker who came to live at Chorley Hall (sited at Chorley Hall Road). Around 1727, Abraham Crompton funded the building of this chapel.

During the Scottish raids into Lancashire by Bonnie Prince Charlie, some of his men stayed in the manse when the Royal Forest of Healey was reached. It is uncertain if the prince himself stayed with the Cromptons at Chorley Hall at this time.

Another fact is that the minister at the church was once one William Tate, He is buried in the churchyard after a period of incumbency of thirty-seven years. His son was Henry Tate, who grew up here. Henry is, of course, known nationwide due for establishing his Tate art galleries.

Park Street Unitarian Church.

Terrace Mount, Park Road – home of the Tate family.

Corner feature on the former Park Road
school building.

Mosques

Chorley today also has a large Muslim community. For a number of years many families
practised their faith in a former public house in Lyons Lane, which served as a local
mosque. It was totally inadequate and a desperate need for better facilities and an
increase in attendances, led to the construction of a new mosque on Brooke Street.

Brooke Street mosque.

Preston England Temple

To conclude our look at the town's churches and snippets of their history we will end this section by looking at the magnificent Temple of the Church of Jesus Christ of Latter-day Saints, known as Preston England Temple. The first celebration on the 15-acre site was the groundbreaking ceremony of cutting the first soil in June 1994. The temple was opened in 1998. The spire is 154 feet tall (47 metres), at the top of which is the golden statue of Moroni. The whole of the building is clad in white Olympia granite.

The temple is situated just north of Junction 8 on the M61 and is seen daily by many hundreds of people passing by on the motorway. The site was chosen due to it being just 9 miles from Preston, where followers of the faith first preached during 1837. Upon their arrival, the missionaries saw a banner being opened out, stating 'Truth will Prevail'. This simple statement was then adopted as their motto.

The Preston England Temple is the largest temple in Britain, with the other being in London. The size of the Chorley building ranks as 52nd in the world.

Many questions were asked when the temple was being built as to why it had Preston in its name rather than Chorley. Over the past few years people have become more understanding of this, and the town is now quite pleased with its rather special 'white church and spire', which has been accepted as 'one of ours' today. It has even put Chorley on the map, so to speak, through people seeing the building as they pass by on the nearby motorway.

Preston England Temple, Chorley.

5. Things We Pass, but Never See

I hope some of the illustrations and anecdotes in this section will help in recalling past places and things we locals did some years ago. Hopefully, some of the images and descriptions will evoke memories of times gone by. This happened to me as I watched the Ambulance Hall in Fleet Street being demolished in May 2017; it was the place my friends and I learned to dance in the 1950s.

In this short chapter, we will look at some of the things in and around the town that we will all know about, but will then look further to discover their hidden histories.

> **DID YOU KNOW ?**
>
> The first proposed railway into Chorley was to be from Euxton and the North Union Railway *c.* 1840. The route to a terminus in Chorley was via Astley Park, then on towards a station built in the Queens Road area.

Flagstones and Cobblestones

First, let's look at what we might come across under our feet. Apart from the precast flags we walk on daily, what about the old irregular flagstones? You know, the ones around 3 or 4 inches thick that you only realise how heavy they are when you lift them. They were not cast from a mixer; they were quarried and dressed to shape individually by hand in earlier times. Today, many areas are without their old flagstones because they are now an essential part of the industrial salvage operative, who acquires the old flags to sell on as a garden feature.

Over the past two or so years – as with many other towns – we have had pothole problems on our streets and roads. Like many other drivers, I have noticed many streets that have large areas of tarmac missing (perhaps 2 or 3 inches of its upper surface), revealing the stone cobbles/setts below.

These cobbles, or setts, are highly sought after in salvage yards. It is quite common that following their excavation, they are not replaced and are removed to sell on. These cobbles have a history. Each may have been handmade by somebody in a quarry in the nineteenth century who was paid a few pennies for each one he produced. But who made them? Where? When? Questions may arise!

When speaking of cobblestones, I always find some confusion with the terms of cobbles and setts. I know one is smaller than the other. The setts are the larger ones used

Left: Seymour Street cobbles in a
fan design.

Below: Fan design cobbles with
a manhole, Devonshire Road.

for road surfaces, while the smaller stones (usually blue or grey in colour) are the cobbles, I believe. It is the smaller ones I refer to here.

Many of these smaller cobbles are set into the ground in a decorative way – a shape, a pattern, even a name. The creation of these works is often from the skill of a craftsman called a pavierre, who would be master in their class, skilled in working out these patterns, and able to do the physical work. In the past, the stone or granite cobbles were secured in place with tar – another product we see little of today.

These ground features are pleasant to see and enhance any area, but if not maintained they can become lost to the community (along with a disregard for the skill of the pavierre who laid them). Cobbled areas are often covered with tarmac; this might be the cheaper and easiest option, but we sadly lose the cobble feature laid with much skill and patience.

There are several areas where the interlocking open-fan pattern can be found in Chorley: off Frederick Street, off Seymour Street, in Back Fazackerley Street, behind houses in Devonshire Road, and off Corporation Street, among others. Many of the alleyways the patterns are laid in are in need of restoration work; some are in need of repair due to damage done during excavation work, and some of them merely warrant a clean and tidy up.

Another issue that is pertinent here is that in Chorley we have a number of back alleys that are completely cobbled. Now, although the cobbles remain, they cannot be accessed due to gates being fitted to the ends of the alleyways for security reasons. I fully endorse the need, but it is often hard to see the cobble work – plain or patterned. Perhaps, one or two examples of these alleyways could be included at annual heritage open days. Or perhaps, there could be a competition between streets for the best back alleyway, having cobbled alleys with plant pots, troughs and large planters.

Wrought- and Cast-Iron Items

There are many questions to be answered regarding the various metal objects we walk over daily. What are these grids and plates for? Why are they here? Who made them and when? Were they made locally? These items are on most streets and in most towns, so we shall now look at them a little more closely.

Historical items of this kind from the sixteenth, seventeenth and eighteenth centuries would have been made by a local blacksmith, usually from wrought iron. The items might include gates, railings, gutter brackets, window security bars and flat strapping for barrels among many others. The nineteenth- and twentieth-century items are likely to have been made from cast or wrought iron – such as or drainpipes and their headboxes, and lids and covers for all manner of access points below a footpath or road. They may well have been produced locally too. Later, items such as large manhole covers and grids are made from steel, which initially would have been produced by a national company.

What other large cast-iron items might we see on the streets? Apart from the disappearing red telephone boxes, you might see a free-standing circular red pillar box – usually found with the royal initials 'E II R' symbol, or even 'G R' if it is one of the George VI boxes.

There is a National Standards measurement plate in St Thomas's Road by the police station. The previous station yard, off Crown Street, used to have a building in which the local Weights and Measures Board office and test rooms were housed.

Town centre bollard.

Town centre lamp post.

During the nineteenth century, with the arrival of the Industrial Revolution, the demand for metal goods increased greatly. This led to the establishment of many foundries big and small, who made as much cast or wrought iron as they could produce. Mills needed many cast-iron columns to support their multiple floors, and machine-makers needed cast-iron components for machinery to install in those mills.

Chorley had several foundries – in North Street, Water Street and Steeley Lane – that produced smaller goods most of the time for domestic use. Heald's Foundry in Steeley Lane also produced larger items such as mill columns, lamp posts, bollards, manhole covers, grids and machine components.

Besides the developing mills in the town there were several coal mines at work: in Clifford Street, Steeley Lane, off Market Street, in Cunliffe Street, behind Pall Mall and on Chorley Moor. All of which had their own demands on the local foundries.

It would seem that the local foundries did assembly work to contract, such as riveting girders together or fitting additional items to girders. Criss-cross strapwork was always a requirement for fencing and bridges for the railways.

At Birkacre, a higher and a lower forge were established along with a slitting mill to produce strapping for barrels – their main product in the early 1800s.

The many smaller items made locally might include small water-shut-off cock valve lids, fire hydrant valve lids, grids for backyards, grids for kerbs, rainwater downspouts and their headboxes, rainwater gutters, mangle components (squeezers), fireplaces and grates, coal cellar covers, shoe scrapers, door knockers, doorknobs, cellar window gratings, railings, and so forth.

Former cemetery water fountain in Astley Park.

Coal cellar cover.

Doorstep shoe scraper.

Building corner protector.

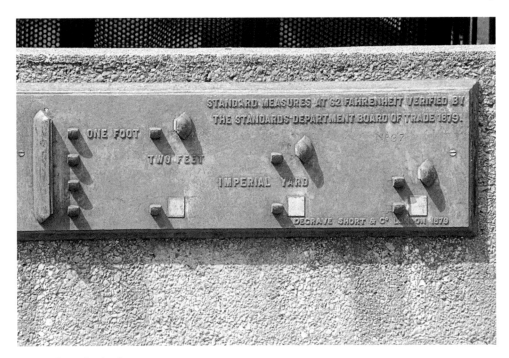

Imperial standards plate.

Water Supplies and Valve Covers

I recently found a water company's shut-off valve cover, dated '1906' with the initials of the water company, 'LCWW'. There are at least two other water supplier valve covers with initials in Chorley with other different water suppliers in the borough villages. One I am searching for, but may never find, may have been made locally for the Chorley Water Co. – if it exists. The arrival of the water supply in the town is another of those aspects that is worthwhile researching.

It all started in Dole Lane, when a deep excavation found clean fresh water accidentally during work for building foundations in 1823. The work of setting up the town's first water supply by pipes was undertaken by a Mr Pierrepoint Greaves.

Several wells were used around the town in the earlier part of the nineteenth century, some with handpumps inside the houses. Some house courts in the town had a single pump from which to obtain their water. Local springs, from which water could be drawn, were also available. There would be several wells in the town, their sites sometimes being found accidentally.

The creation of the Liverpool water catchment area of the local moors during the 1830s led to the city obtaining permission to build a system of reservoirs between the local moor upland and Chorley town. Their concentration of reservoirs in the borough of Chorley was (and still is) in the parishes of Anglezarke and Rivington. They were connected by a water canal ('goit') to reservoirs further east at Abbey Village. A water purification works was built at Anderton, also in the borough of Chorley. Fresh water is still supplied from Anderton to the city of Liverpool.

The water supply to Manchester also passes through the east valley of Chorley, inside large diameter pipes visible at some local places, but mostly underground. This is the Thirlemere Aqueduct pipeline from Thirlmere Lake in Cumbria. This supply also provides Chorley with its drinking water.

The early nineteenth century saw a new Chorley Water Co. formed, who, following negotiations with Liverpool, reached an agreement that Chorley Waterworks would be independent and have its own reservoir at High Bullough. This water would be gathered from moorland streams above Lead Mines Clough, but this proved to be inadequate and water was then obtained from the Liverpool-owned Anglezarke Reservoir by underground pipeline.

A separate Chorley waterworks was built with its own purification system of header reservoir, filter beds, etc., on Healey Nab, Crosse Hall Lane, in 1836. The town water header tank (for pressure) was obtained by a water tower with a tank located between Hartwood and the Sea View pub. It was one of the landmarks people noticed when entering the town from the north. The header tower was discontinued when the Chorley water supply was changed to the Thirlemere supply.

That old landmark for travellers on the A6 road north of the town has been superseded – due to its location only – by the elegant spire of the Church of Jesus Christ of Latter-day Saints at the Preston England Temple.

Above and opposite: Water covers with the company's initials: 'LCWW' (Liverpool, 1906), 'MWB' (Manchester), 'NWWA' (North West).

Looking down onto our footpaths, one discovers a surfeit of large and small shut of water-cock valves and covers, each with its small hinged lid and usually accompanied by others stating 'GAS' or 'FIRE HYD'. But some of these unnoticed metal items under our feet are gradually disappearing. Some are being superseded by upgraded covers for the same companies, such as the metal covers with aggregate top filling, stating 'POST OFFICE TELEPHONES'.

Iron Railings and Gates

If one heads to Chapel Street and walks to the left, a short distance up the street you come to an open view of St George's Church, which has newer railings around the former graveyard. Its original railings were taken for wartime scrap, as was the case with most others in the town. Opposite the churchyard are some of the former 'up-step' houses with cellars. These still have their original railings, I believe, by the steps down to the cellars.

Pass the end of Clifford Street to the town bypass road to arrive at Chorley railway station. The railings at the side of the pedestrian subway to the right were left in place in the war years. They had been made in Burnley around the 1890s; the maker's name is more visible on the railings at the far side of the subway.

During the war years, many sets of iron railings as well as road signs were removed during scrap-iron collections. In Chorley, we have a few sets of railings and gates that were not removed, two of which have names on them.

Return to the front of St George's Church and walk down St Georges Street and across Market Street into Peter Street. To the left is the rear entrance to the Rawcliffe Hospital; its original railings and gate are still in place.

Chorley railway station subway with 1890s railings.

Other sets of railings left in place during the war years are to be found at the front of Chorley parish churchyard in front of the tower; along Park Road, from the church gates to opposite Astley Park gates and the gates themselves; and the fencing that formerly enclosed Eaves Lane Hospital grounds. Some of the latter still remains in place, including

Above: Old railings on Park Road.

Right: Former Eaves Lane Hospital railings.

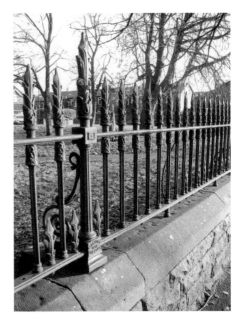

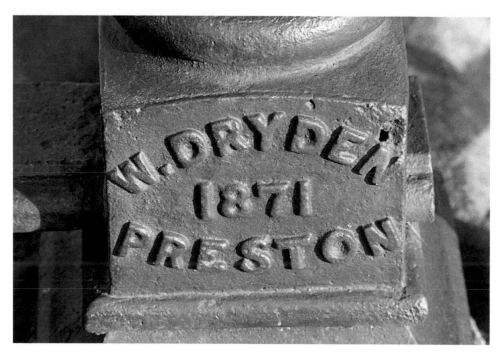

The maker's name and date can be seen on the railings.

Dutch-style houses in the Brown Street area.

the supporting columns (where you can spot the maker's name), which were made by Dryden's of Preston in 1871. The former Parish Church School in Bengal/Water Street still has some original railings and a gate in place. Park Street Chapel is also a possible site where original railings can be found. Take some time to have a look around for yourself as there may be other sets of original railings and gates to find in and around Chorley.

Look Up!

This last category is one that requires us to look a bit higher than we have been doing so far – up to roof level, and sometimes higher.

After the age of oil lamps, the first street lighting was by coal gas from 1819, with the first gasworks introduced in the 1820s. Electricity first arrived in Chorley's streets in the early 1950s with a big switch on along Market Street of white neon lamps. Despite this, gas-lit streets were still around into the 1960s. Many of the old gas lamps had their tops changed and electric wiring fitted to convert them to electricity. As previously mentioned when discussing foundries, some lamp posts were made in Chorley at Messrs Healds Foundry in Steeley Lane. The locally made lamp posts had the maker's name on the fluting, which read 'Messrs Heald and Co. Chorley' or 'Healds Foundry, Chorley'.

A large number of the locally made cast-iron lamp posts were converted and then gradually replaced with concrete posts and/or other metallic posts and types of lamp. I am told some of the old Chorley-made posts were purchased from the local council. The last I saw in use was on Water Street many years ago.

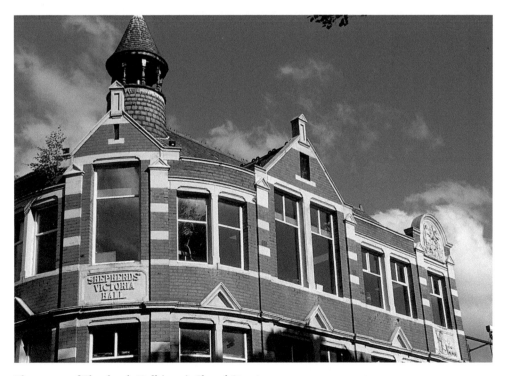

The corner of Shepherds Hall (1903), Chapel Street.

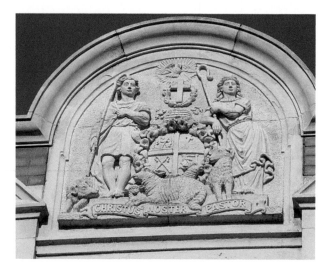

The upper wall plaque on the front of Shepherds Hall, Chapel Street.

The lower wall plaque.

'Beehive Building'.

Some features to be found on buildings include date stones, shop names or advertisements, architectural details, or a personal choice of items by shop owners or even a builder's whim. Not so high we can find 'dragons' in Devonshire Road, Kensington Road and Harpers Lane; we have weird beasts on Chorley parish church and more strange animals on the tower of the library building in Union Street; we have carved stone date stones on the former Rawcliffe Hospital; and we can't forget the two religious plaques of the Shepherds Hall.

What of the so-called Beehive Building and its carved stone plaque – you will all know where this is, I'm sure. If you know about the Beehive, you probably will know where the other Beehive was as well, despite it having been demolished. (This particular piece of Chorley history is being researched by a historian colleague.)

To end this section, here is something to look out for around the town. Where is this plaque located that states 'Palais de Danse'?

'Palais de Danse' – where is this?

6. People and Places

When looking at local photographs of yesteryear, you can often spot people you may know or places you may remember. In this chapter, we will concentrate on the 'secret' aspect of these people and places. In some cases, the location may have changed from the time the image was taken.

I like to use a magnifying glass to see more than is first visible on old images, so I can read the signs and posters of the time or look at the fashions people wore. People on charabanc trips to the seaside have men wearing a collar, tie and flat caps, even bowler hats, and the ladies have big hats and long coats – not a pair of shorts in sight, nor even a smile! I hope you consider the photograph of St Mary's Church Ladies Cycling Club of the 1890s as I did. How did their long skirts avoid getting entangled with the wheels? I refrained from showing an image of the male cycling club for I thought them a too untidy compared with the well-dressed ladies in their long skirts and feathered hats.

This, then, is what follows: we shall look at some of these older images a little deeper to see what we can uncover – enjoy the nostalgia, and a few secrets shared.

DID YOU KNOW ?

In 1643, Major Edward Robinson of Buckshaw Hall was captured by Lord Molyneux's men and imprisoned at Lathom House. During his incarceration period, he wrote the book *A Discourse of the War in Lancashire*.

Promotional Float

We start with an image that I know for certain no one will be able to look at it and say 'that's me'. Some of the men on it could be have been great- or even great-great-granddads to some Chorley people of today. I only wish old images came with names on the back of the photograph, but that would make research far too easy!

The date of the opposite image is 1879. The occasion was the opening of the new Town Hall, when a procession took place in Chorley to show the people of the town how the local gas supply was made at the nearby gasworks. The works had only been open since the 1820s, and by the 1870s it was being enlarged to cope with demand.

It's uncertain exactly what is being displayed here. There seems to be a fireplace with a chimney for burning coal to produce gas, a system of coolers and containers for gas, and lamps to be lit with the gas produced, so it seems this could be a mini-gasworks on a horse-drawn

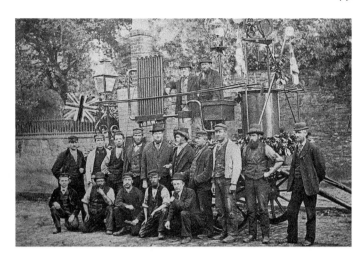

An 1879 promotion float
for gas supplies.

wagon. The men don't look too happy, possibly because it's been a long day with the procession. There are two men with a faint smile, which you can spot if you use a magnifying glass. I think the location of the photograph is Water Street, close to the original gasworks.

Cattle Fair

To get our bearings, the building to the left is today's Imperial public house, which was extremely busy on cattle fair days. The pub, I am told, had a different name then, but it has not yet been confirmed what it was. There is a water trough outside the pub and many carts in the distance to the right are seemingly on higher ground than the level Cattle Market (the later Flat Iron Market) would be.

To the left, within the semicircle of people, is a man with a small cart. This was a local character called William (Bill) Harrison, who was both a butcher and a publican. Both of his shops were side by side in Market Street. No doubt when this image was taken he had been eyeing up his supply of meat for next week at the fair.

By the early years of the twentieth century, the cattle were held in railed compounds on the south side of the market, where the entrance to today's Market Walk is. These railed

Cattle market, *c.* 1890.

areas were still in place into the 1950s, with a totally enclosed area having been created at the south-west corner of the Flat Iron. Here, overnight pens for the animals were available for farmers having brought animals from some distance away. The overnight pens were removed during the mid-1950s. Until then you would often hear the cattle calling at night; with the lowing of the cattle, central Chorley sounded like the countryside.

While speaking of cattle in the town, until around the 1970s there was a slaughterhouse in Chorley, situated where Asda car park is today. Occasionally, cattle would escape and be chased down and around the Bolton Street/Pall Mall area. It was like a Wild West show, and great fun for those of us who could see the funny side of these chases, but for some reason we got told off for laughing. Especially on one occasion when an animal went down an entry into a backyard, which had an outside toilet with an open door, where someone was having a quiet read until a cow's head appeared over the top of the newspaper – no doubt the person 'reading' would have had a rather big surprise!

Lady Cyclists

Moving next to the end of the century – 1899 to be precise. That year on 9 August the Ladies Cycling Club of St Mary's Church went out for a ride. Their meeting place, as shown on the accompanying photograph, was to the rear of the Town Hall in St Thomas's Square, usually called the Town Hall Square. It was here that bicycles were checked and clothing would be compared.

In the distance to the left is the entrance to Back Mount (and the Red Lion Tap), with Mealhouse lane beyond. The building on the nearest corner was offices in the 1950s, and just around the corner from my parent's home, where today's rear entrance to the courthouse is located. Beyond the office in Mealhouse Lane is the later British Legion Club, originally a public hall. In this hall the first moving films were shown in Chorley. Also, just visible at the far end of the lane, are the rooftops of the former Red Lion public house (today's White Hart site).

Note the group of men – one cannot help but wonder what they are discussing. One of the men is actually laughing, which is quite a rarity on images from this time. I have another image showing the ladies setting off on their ride, accompanied by a reverend – probably the chaperon.

Two of the favoured local places the cyclists went to were in the Whittle le Woods area, where they could sample the spa waters, have a picnic on Whittle Hills, and enjoy views to the sea 20 miles away to the west.

St Mary's Church Ladies
Cycling Club, 1899.

Church rally pre-1914 on 'Flat Iron' – possibly Trinity Church.

Group Rally

Like so many old images I am either given or lent to use, most usually have no information on the back. This is one of them.

If a magnifying glass had not been used I would not have known anything about the details of the photograph, other than it was a meeting or rally of some kind; but, I knew the date.

Mr Testo Sante, who lived in Hollinshead Street, was quite the entrepreneur of his time: a magician, strong man and circus performer, who had established a skating rink in the former drill hall, which later became the Pavilion Cinema. This venue was also used for band concerts until Mr Sante created the huge Sante's Theatre on the Flat Iron market site. It was built entirely of wood and had an upper balcony. His prices, it seems, were well favoured by the general public and the theatre was the only 'real' one in Chorley. Another theatre was built a little in Market Street: the Theatre Royal, which opened in 1911.

The old photograph here reveals new information from the time: the huge 'big lamp' in the centre of the marketplace, four mill chimneys can be seen, there is a military group at centre distance, there is a horse-drawn wagon (possibly a float) with children on it, and several young ladies dressed in white to the left side – perhaps a 'Walk of Witness' for the Methodist churches.

The two banners on the side of the building to the right refer to Trinity Methodist School and Church. And how did I know the date of the image, as mentioned earlier? The building on which the banners are leaning on is the side of Mr Sante's Theatre, which burned down in 1914, meaning the photograph must predate that fire. Any feedback on this image would be of interest to the author.

Circus Parade

This image, at least to some degree, speaks for itself. We have a scene in Market Street looking towards the old St George's School in the distance. And what a scene it is. The street is lined with people; a large coach leads the parade in which a band may be playing, all pulled by six horses; and a troop of cavalry follow, along with more horse-drawn coaches and wagons.

Sometimes having information of the back of an image can lead to more questions; this is true here. The back of the image stated that this was the circus of Bronco Bill – there was a

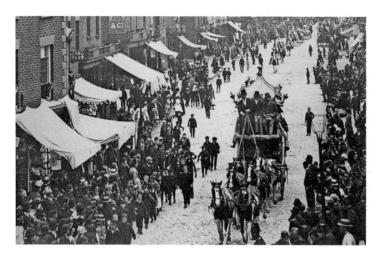

A circus comes to town.

touring circus of Bronco Bill?! I know of another circus that came to England from the USA that was headed by Buffalo Bill Cody aka the famous Buffalo Bill, so a little more investigation is necessary to discover which circus this was and whether it played in Chorley or was just passing through. What is certain is that it attracted people into the street to watch the parade.

As regards Market Street buildings. Note to the left the sign for Messrs Booth and Co. at the bottom of St George's Street. Messrs Booth and Co, were/are a Preston Company and Chorley was the first town the company established a shop, outside of Preston.

War Memorial

In the year 1919, Mr Reginald Arthur Tatton offered Astley Hall to the Corporation of Chorley to become part of the town war memorial. A group, already having been formed to take the war memorial proposals forward, was known as the War Memorial Scheme. Members of the scheme had already expressed an interest in using a part of the Astley Hall estate land for the memorial, and this was yet under discussion. Mr Tatton later complied with the scheme proposals and gave the whole of Astley Hall and Parkland to be Chorley's war memorial, where a town cenotaph would be built.

The Hall and the park were officially opened by the chairman of the Parks Committee, Alderman A. Gillett. There were official processions and speeches, and large crowds in attendance on 31 May 1924. The cenotaph was dedicated by Revd Bishop Hill of Hulme.

The old postcard view shows a huge crowd around the Astley Park cenotaph, with children nearby whose fathers had not returned from the war. It is uncertain if this view dates from 1922 or 1924 as the postcard is unused.

The cenotaph's column design is based on the former town obelisk, which stood on Town Green (St Thomas's Square) and was later incorrectly said to be the market cross. The obelisk, with its stepped plinth, was used by the town bellman when notices or special event information was read out. Sales took place alongside it and whipping punishments were carried out at the obelisk. It is also recorded that a wife was sold here. A separate market cross was sited in Market Street itself, which was lost during road and building works in the eighteenth century.

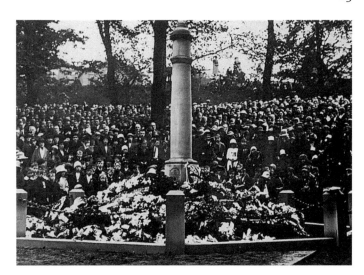

A war memorial and
cenotaph for Chorley.

Longest Queue

This view dates from August 1946. The location is Cleveland Street as viewed from an
upstairs rear window in the Royal Oak Hotel, looking over the car park to the single-storey
sorting rooms of the post office. This would later have a two-storey addition above it, but
not in stone as per the original attractive building at ground level. Incidentally, this was
used as the town's post office until early 2017, when it was relocated for the fourth or fifth
time; it has now reduced in size to become part of a bookshop.

Can you see the people queuing on the footpath, all facing Union Street? This is
because the bus station was located off to the left of the image. You may wonder why
there's a queue, which is what I had to search for and it came as a surprise too. The queue
was there because the Royal Lancashire Agricultural Show was being held in Astley Park,
with visitors coming from some distance away – largely, it seems, by bus – who were now
awaiting their buses to go back home.

Possibly Chorley's longest
ever queue!

7. Industry, Landscapes and a Legacy

As this is to be the last chapter of the book, I thought it would be suitable for us to appreciate what we have around us. There are many more local sites not included that I would like to have covered but space does not allow.

We begin our overview of some former industrial sites by looking at the earliest powered mills, as opposed to animal powered. At least two mills formerly driven by a gin-horse are in the Chorley area. As Chorley has rivers all around it – the Chor, Black Brook (real name Bagin Brook), the Yarrow and the Douglas (real name Asland) – it is hardly surprising that we had water-powered mills locally from the thirteenth century. A 1230 date is the earliest recorded locally, with more during the fourteenth and fifteenth centuries at Astley, Crosse Hall, Birkacre, and at Euxton, Eccleston and Croston village.

A gradual move to a more varied use of the water-powered mill came during the seventeenth century with Fulling Mills (previously called Walk Mills), when the Fullers Earth composition – in powder form – was worked into the cloth by people walking on it in water. Later, large water-powered wooden hammers were used to raise the nap of cloth. We had Logwood Mills locally, who removed and crushed tree bark. Dyes became a necessity to use as more woven goods were being produced that were in need of some colour. This industry developed further into bleaching and dying, still using water power until the coming of the steam engine in the late eighteenth century.

DID YOU KNOW?

From the late 1830s, Frederick and Richard Cobden managed a printworks off Cowling Brow in Chorley. It was Richard who became involved with politics and was much involved with the movement for the repeal of the Corn Laws.

Regarding local watermill sites, until a few years ago we had four. Two of these were below ground; of the other two, one was above ground ruined, and the other overgrown. I requested developers allow a limited excavation and possible retention of the ruined site. This was refused and the mill was built over, despite its fifteenth-century origins. This site was at Crosse Hall Mill Farm.

The other site remains overgrown, but could be made into what is called a 'consolidated ruin', showing building outlines and interpretation boards. This particular site happens to have its origins in the thirteenth century.

Lead Mining

As well as the local moorland areas being a source of water for local rivers and later reservoirs, there was also lead to be found in some of these areas. Mining was carried out in two sites with intermittent stoppage periods. As to dates of working, it is difficult to determine. The earliest known certain date is the eighteenth century; however, in view of some dating evidence (such as pottery being found), it may have been as early as the sixteenth century when the mines were worked.

There is an interesting waterwheel pit at one of the mine locations, which had a water supply to it via wooden troughs from higher up the hillside to drive the wheel and a water pump. It also drove hammers to crush the lead ore before heating, to remove the lead from the ore.

Today, one of the pleasures of a picnic visit to the area known as Lead Mine Valley (or Clough) is that the associated stream, the River Yarrow, is a favourite paddling location to search for pieces of galena or lead ore – a popular pastime for parents and children alike.

A further aspect of the lead mines is that another mineral was discovered here that was used in the manufacture of specialist china pottery and was highly sought after. It is even recorded that pottery manufacturers from Germany came here to obtain it by either fair or foul means. The mineral is referred to as witherite, which has the appearance of a semi-transparent piece of soap. Apparently it is only associated with deposits of lead ore: galena.

Lead Mine Valley.

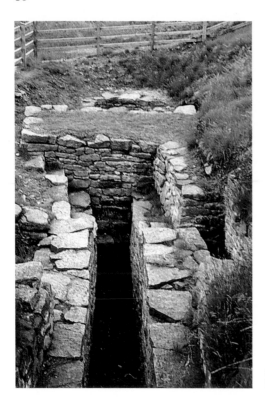

An excavated waterwheel pit and pump shaft, Lead Mine Valley.

Lancaster Canal

Moving from lead mines to canals and the decade of the 1780s, when the canal was cut from the Lancashire Coalfields near Wigan to run north via Burscough, Wigan, Chorley and Preston then on to Lancaster and Kendal. This was the Lancaster Canal.

Its main purpose was to carry materials from Wigan to Lancaster, then back to the Wigan. The loads each way were guaranteed with coal moving from south to north (Wigan to Lancaster), and wagons coming south would carry limestone. The limestone would be used on farmland or by builders for lime mortar.

The canal was cut through Chorley during the mid- to late 1780s, during which time surveyor/engineer John Rennie created an aqueduct here.

A major problem was the crossing of the Ribble Valley – from Preston to Clayton Brook in Chorley – where a three-arm basin was built at Walton Summit. A horse-drawn railway was built from Walton Summit to the River Ribble and a bridge was built at Avenham, where the wagons were hauled up an incline by a steam-driven cable to continue by horse tramway to the canal basin in Preston. The proposals for crossing the Ribble Valley remained using horses, and was operated from 1803 to the 1860s.

The Leeds & Liverpool canal joined the Lancaster Canal at Johnsons Hill, 2 or so miles north of Chorley, where locks were built. Adhering to an agreement, the Leeds Canal Co. did not build an additional canal between Johnsons Hill and Liverpool, they paid toll charges to the Lancaster Canal Co. for the use of their canal facility. The date of the canals being joined was 1816.

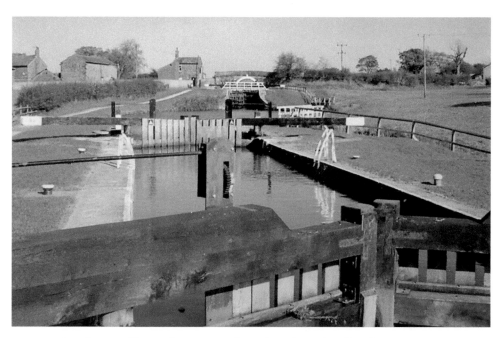

Lancaster Canal is joined by Leeds & Liverpool Canal at Johnson's Hill Locks.

Railway Flying Arches

While discussing canals and railways, one of our recently 'altered' local architectural features concerns the Bolton–Preston 1840s railway. The surveyor–engineer on this project was Mr Alexander Adie. The work started at the Bolton end of the line in 1841 and progressed well to Chorley, which is where the first major hold-up occurred – due to the nature of the ground. There was a hill beyond the town that had to be tunnelled to run the lines down to Euxton, where it was hoped it would join the North Union Railway (running between Wigan and Preston from 1838).

The tunnel at Hartwood Green proved to be a major problem due to the number of springs with 'running sand' occurring. Steam pumps weren't of major use either, due to the volume of spring water having to be pumped away.

As a result of the major hold-up of construction work due to excess water, it was decided that the proposed 300-yard tunnel would be reduced in length to 100 yards in the middle with open cuttings at each end. To the Euxton side of the tunnel, the cutting had to be steeply angled due to the presence of buildings and parkland. It was here that Mr Adie built a series of sixteen arches to span the cutting and brace the side walls. These 'flying arches' were built in 1842/43, spanned some 25 or so feet, and had a single course of stones in the middle of the span. They remained unchanged from then until around 2010 (or thereabouts), when we were informed that the railway line from Blackpool via Preston, Leyland, Chorley, Bolton to Manchester was to be electrified. This meant the tunnel and stone arches would be too low to accommodate the overhead wiring for the electric trains. The tunnel track had to be lowered and the arches were removed (after much protest due to their uniqueness nationally). Network Rail removed the arches by sawing through their

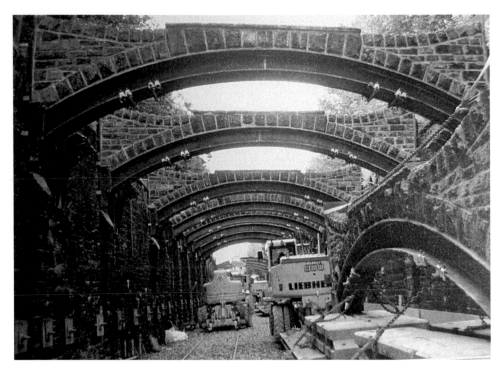

The 1840s Adie Arches with steel supports, 2014.

ends and fitting them into steel cradles. Steel arches were then fitted across the cutting in the same locations that the stone ones had been, with the stone arches being lifted on top of the steel arches. The original stone arches had now been raised and supported – an old and new legacy combined. It was a great feat of engineering, but it was unfortunate that they could not have remained as they were and the trackbed been lowered instead.

Rivington Reservoir System

Having previously discussed the installation of a water supply in Chorley, as well as discussing excavation work, perhaps we could look at some greatly favoured local beauty spots around Rivington Village – a bit of Switzerland in Chorley.

The four large reservoirs within the Rivington and Anglezarke parishes are linked by a canal (the Goit), which flows through the villages of Brinscall and White Coppice from another reservoir at Abbey Village, called Roddlesworth. The whole of this huge undertaking creating the reservoirs within flooded valleys began in the 1850s and lasted into the late 1870s.

The last to be built was Yarrow Reservoir, which takes water from the local moors via Lead Mine Valley. An outflow from Yarrow Reservoir goes into the lower Anglezarke Reservoir.

There are four reservoirs at Rivington, with another at Roddlesworth, Abbey Village. The water flow through the system begins at Roddlesworth and heads along the canal (Goit) via White Coppice, where an overflow takes excess water from the canal to provide

The overflow stream from the Goit, White Coppice.

water along with and a small moorland stream to a former bleachworks water lodge, then continues past White Coppice to Anglezarke Reservoir. Water also runs into Anglezarke Reservoir from Yarrow Reservoir. Another overflow from this reservoir supplies water to the river and continues to Yarrow Bridge, where it is joined by Black Brook. The combined rivers now become one: the River Yarrow.

The main outflow from Anglezarke Reservoir heads into the Higher Rivington and then Lower Rivington reservoirs, before going on to the filter beds and then is finally delivered to Liverpool.

The length of the system is approximately 10 miles, and the water catchment areas for the reservoirs is all from the high moorland surrounding the reservoir complexes.

Yarrow Valley Park, Birkacre

Birkacre is an odd name as generally areas with 'burgh' or 'berg' in old English are said to mean a 'fortified place', but this doesn't appear to be the case here. I have tried to obtain more information about this but have had to put it aside for now due to so much being unknown. Further investigation would mean trial excavation at several sites on private land, so this will have to be left for the time being. Perhaps, it could be raised at some later stage if local interest increases and if time and health permits.

Birkacre has been written about in documents as old as the fourteenth century that are related to the building of a water-driven corn mill. Another mill was later built by a Mr Chadwick of Higher Burgh Hall in 1770. This mill was leased to one Richard Arkwright, who fitted the building with his latest water-framed spinning machines.

River Yarrow weir, Yarrow Valley Country Park.

This was the time of the machine breakers, who attacked the mill and held it under siege; this ultimately led to people being killed and the mill getting burned down. Arkwright left the site in 1779, but the seeds of the cotton industry were sown in the district. It was only some twenty years later that the first steam-powered mills were built in Chorley and, with them, the birth of the town's cotton manufacturing heritage began.

Early Twentieth-Century Cotton Mills

Out of the borough of Chorley's cotton mills – approximately thirty-five at the industry's height – most are now demolished. There are a few – perhaps four – remaining mill buildings dating to the pre-1900s era, with a further two in the borough of a post-1900 date. One of these two is Coppull Ring Spinning Mill, which was fortunately saved and is now a listed building. It is was well used and cared for, and dates from 1906.

In Chorley we have the five-floor Cowling Mill that is crying out for preservation and sadly falling into disrepair, yet in many Lancashire towns to the east of the county properties like this are being transformed into apartments and flats. Many of these have roofs and floors partially removed to create a stepped-feature building of style and character with arched or glazed spaces for games and social events.

We lost our grandest mill a few years ago at Talbot. I recorded its 'passing' while working along with the demolition contractors. I am not on my own in wanting to see

the last of Chorley's twentieth-century mills preserved. It should be safeguarded for the future and with careful alteration it could become a feature building in the town. Having put this question to certain local officials, I have been told: 'We already have a listed mill in Coppull.' Fair enough, but why not one in Chorley?

During 1900–08, between Bamber Bridge, Chorley and Coppull, five large multi-floor cotton mills were built. All were of a similar architectural style and containing similar machinery and engines. There was one mill in Bamber Bridge, two in Chorley, and two in Coppull. We are now down to one each in Coppull and Chorley.

Despite its dilapidated condition, Cowling Mill still has terracotta features, which could really make the building stand out if they were enhanced or restored. Forget the outbuildings, save the main mill! Surely there is a need for a building such as this to be used again, despite it being over a century old.

Former Ring Spinning Mill, Coppull.

West side of Cowling Mill, Chorley.

Widdows, Botany Mill

Of the older mills in Chorley, we have one survivor from pre-1900 that is still in use and a hive of activity on a daily basis, with visitors and shoppers alike. It can be seen by people driving along the M61 as it stands close to the east side verge close to Junction 8 at Chorley North, where the photograph was taken.

This is the well-known and advertised Botany Bay. Formerly a cotton-spinning mill and having seen many changes of use since those days, it is still in use today with shops, cafés, a garden centre, children's activities and more. Inside the building are many features relating to its past history and there's still a lot to uncover about it – the mill building and the column makers for a start. Botany Bay is a great example of just what can be done with an old multistorey mill.

Lord Leverhulme

I have already spoken about Lord Leverhulme and the amazing legacy he left behind for us to enjoy today – his gift of Lever Park at Rivington, along with his former Moorside

Botany Bay Mill.

A view of Rivington Pike, a former 1588 Spanish Armada warning beacon site. It is viewed here from the north-west, over Lord Leverhulme's donated Lever Park and towards Rivington Village. To the hillside in the distance on the left trees cover the terraced gardens, which are awaiting their new phase of consolidation before long-term future restoration to their original 1920s design.

bungalow with terraced gardens and buildings. Although he did not create any local industrial features (or, as he used to say, 'his Rivington'), with his business acumen and what he earned from it he was able to create what he left for us today.

Our Town

We'll end this book with a view of Chorley taken from halfway up Healey Nab. It is a town luckier than others, which have lost not just their heritage but their scenery too. In Chorley, we still have both of these.

The image here shows where we live, situated between moorland (behind the camera) and the sea on the distant horizon, across the Lancashire Plain.

Our legacy as an industrial town has perhaps been overlooked, but our local scenery is still a great asset to enjoy today and in the future.

I hope the reader has learned a little more about Chorley and its past from this book and looking closer at the things we see each day as we pass them by but perhaps take for granted. At least some of my own 'secret' discoveries are recorded here, but many more remain untold. Enjoy our heritage and legacy while it's here to discover – some of it could be gone tomorrow!

View over Chorley to the west coast – from Healey Nab.

Bibliography

Bagley, J. J., *A History of Lancashire* (1956).

Birtill, G. A., *The Church on the Brow* (1968).

Birtill, G. A., *Follow Any Stream* (1968).

Birtill, G. A., *What Mean These Stones* (1965).

Birtill, G. A., *The War and After* (1976).

Blackburn, R. H., *Borough of Chorley, Jubilee Souvenir, 1881–1981* (1931).

Cesinsky, H., *A. Report on Astley Hall and its Contents* (1923).

Chorley Borough Official Guides (various years).

Duffy, M., *The Sacred Heart, Chorley* (1993).

Edwards, B. J. N., *The Romans at Ribchester* (2000).

Farrer, J., *Victoria County History, Volume VI: Leyland Hundred* (1911).

Gillett, T., *The Story of Weld Bank* (1974).

Gillett, T., *Tales of Old Chorley* (1981).

Graham-Campbell, J., *The Viking World* (1980).

Haworth, G., *Guide to Astley Hall* (1981).

Heyes, J., *A. History of Chorley* (1994).

Hodkinson, K., *Old Chorley (In the Footsteps of Wilson)* (1988).

Mannex & Co., *Directory of Preston and Chorley* (1851).

Nevell, M., Roberts, J., and Smith, J., *History of Royal Ordnance Factory, Chorley* (1999).

Porteus. T. C., *A. History of the Parish of Standish* (1927).

Porteus. T. C., *Astley Hall, Chorley* (1923).

Shotter, D., *Romans and Britons in North-West England* (1993).

Smith, J. G., *Chorley & District* (1994).

Smith, J. G., *Chorley Remembered: The 50s, 60s and 70s* (2002).

Smith, J. G., *Chorley Borough Through Time* (2012).

Smith, J. G., *Chorley Then & Now* (2013).

Acknowledgements

I would like to thank the following councils, businesses, organisations and individuals for their help and co-operation in compiling *Secret Chorley*: Lancashire County Council and Lancashire Record Office staff; Harris Museum and Library staff; the library staff at Chorley, Adlington and Standish; the Planning Department of Chorley Council and conservation officer Mr Ian Heywood; Messrs DUCE, Chartered Certified Accountants, for photography access; Town Hall staff and local councillors; Network Rail for access while photographing work upgrading the tracks; Mr I. Lord, manager of Gala Bingo in Chorley, for access to the former Odeon Cinema; and Messrs E. Wright, Construction Group, for access to the Fleet Street Primrose Court site for photography.

A special thank you goes to Barbara Morgan, who has helped with editing and suggestions, as well as sorting my computer glitches again.

My thanks go to past local photographers for images they took in years past, and also to owners of photographs previously purchased by *Chorley Guardian* readers that have been loaned or given to me. Thank you again to *Chorley Guardian* staff for allowing me to use these images.

To Wilf and Norma Culshaw in Portugal, Robert and Elizabeth Ward in France, Mr Ron Clayton and family in Cheshire, Mr S. Whalley and family, Barry and Teresa Holding, Jim and Pat Monks, Mrs D. Firgarth, Mr and Mrs Ellis, Mr and Mrs John Harrison, Mr and Mrs Paul Tate, and Mr and Mrs Alan Catterall. Also to the late G. Birtill, J. Shaw OBE, L. Chapman, T. Hull, T. Gillett, former Mayor C. Williams JP, and also to the late Margaret Rawlings. All are friends and historians who are sadly missed, and whose photograph collections and writings I have consulted from time to time.

And not forgetting many local people who have shown an interest in this project, and those I have interviewed or chatted with in the street or at Masons Market Café.

Many thanks to one and all for your contributions and support.

About the Author

The author has lived in and around Chorley all of his life, served an apprenticeship to Heavy Engineering at the former Horwich Locomotive Works near Bolton, and attended the adjoining Mechanics Institute. Following his apprenticeship he spent a decade at sea as a marine engineer with the P&O Company. Back on shore he worked at a boiler and steam plant and has carried out mill maintenance at several of Chorley's mills. He has also worked in the inspection department at the local Royal Ordnance Factory.

Jack sits on the north-west region of the Council for British Archaeology, and the Industrial Archaeology Panel. He was a founder member of the Chorley & District Archaeological Society (now Historical and Archaeological Society), serving thirty-six years as secretary and editor. He is also a board member of Rivington Heritage Trust.

Jack is also a programme organiser for the BAE Warton-based Railway Transport and Industrial Archaeological Society, a member of the U3A, and is currently researching the industrial history of Chorley and compiling an Apprentice Autobiography.

Jack's other books for Amberley Publishing are *Chorley Through Time, Southport Through Time, Lancashire Coast Through Time* and *Secret Southport*.

The author, with contractors, recording mill demolition.